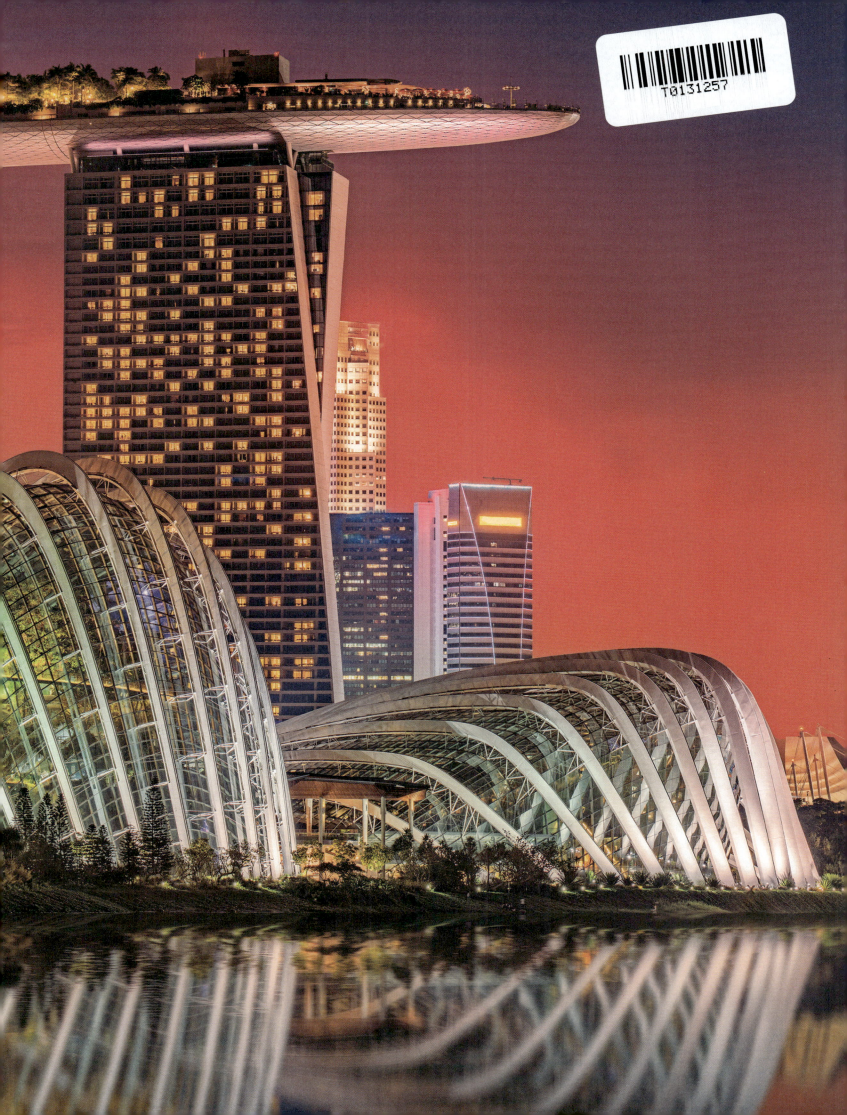

# JOURNEY THROUGH
# SINGAPORE

A Captivating Portrait of Singapore—from Marina Bay to Changi Airport

Welcome to the dynamic island nation where East
meets West and the past meets the future

**TUTTLE** Publishing

Tokyo | Rutland, Vermont | Singapore

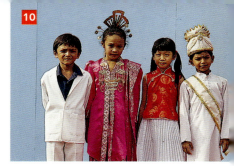

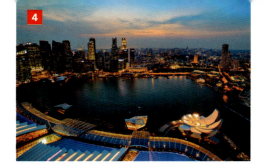

# JOURNEY THROUGH
# SINGAPORE

On the surface, Singapore appears to be a brash, modern city just like many in the West. But beneath this veneer you will find a fascinating blend of Asian cultures. It is a nation at a crossroads, as Stamford Raffles realized when he 'leased' the island for the British in the nineteenth century. He turned the island into a thriving trading port between East and West. Mass migrations from the region and elsewhere further transformed Singapore. In 1959, the British granted Singapore self-governance. An attempt in 1963 to merge with Malaysia failed due to tensions in the alliance, thus in 1965 Singapore became an independent nation. Strong leadership led to a new and modern Singapore: safe, clean and successful—a wealthy little country with a big reputation.

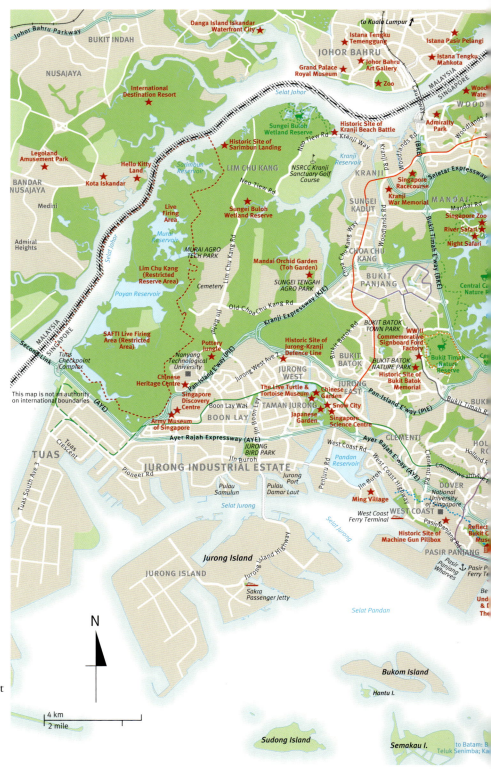

This map is not an authority on international boundaries

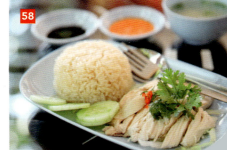

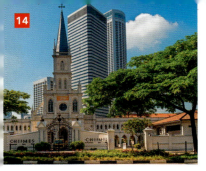

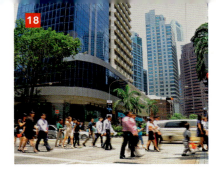

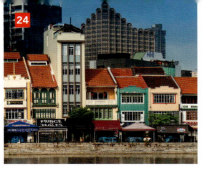

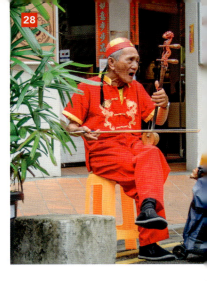

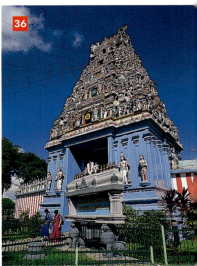

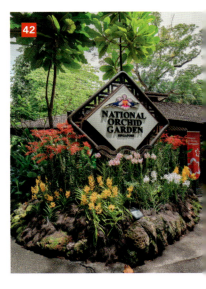

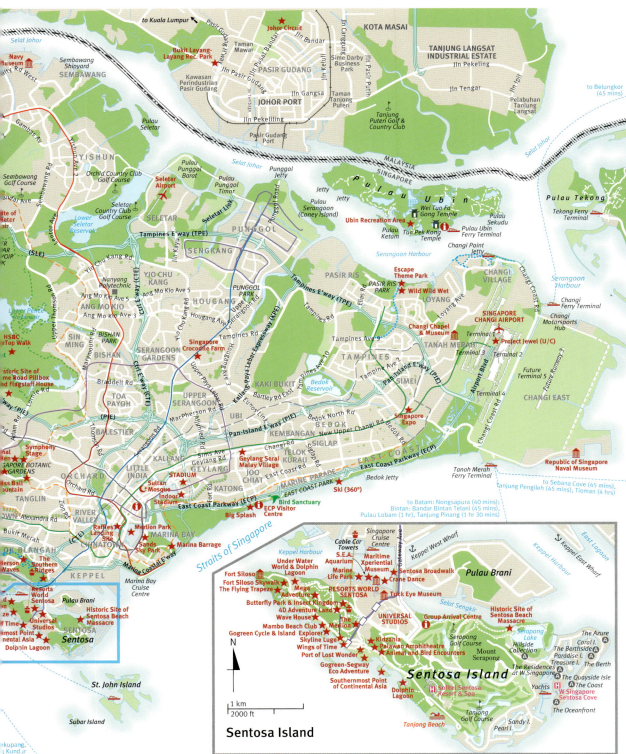

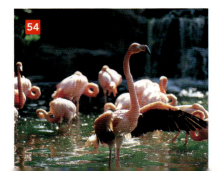

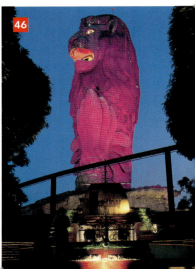

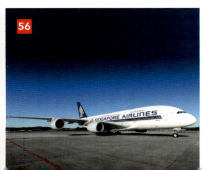

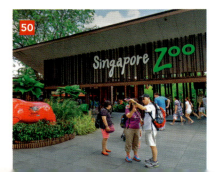

# Welcome to the City of the Future!

Singapore is hot, not just because it is nearly on the equator but because of all that is happening here. This proud nation continues to stride confidently forward in the twenty-first century.

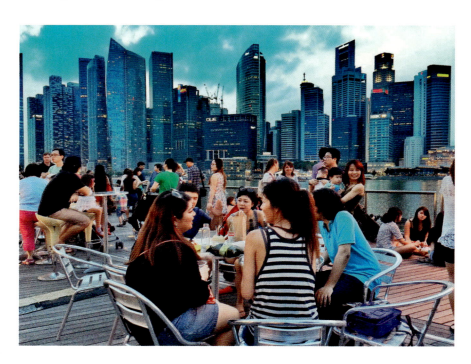

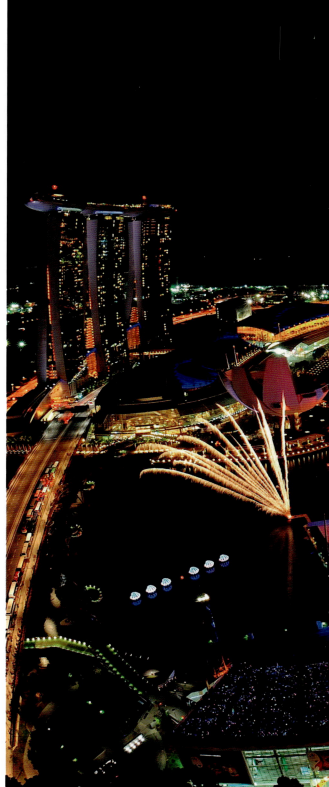

**Above:** Restaurants and bars line the waterfront of Singapore, making it a scenic place to chill out after work.
**Opposite:** A fantastic fireworks display at the world's largest floating stage—the Float@Marina Bay—to celebrate the country's independence day on 9 August.
**Opposite top left:** The half-fish, half-lion Merlion is Singapore's official mascot.
**Opposite top centre:** The world's first Formula One night race has been held in Singapore since 2008.
**Opposite top right:** Over 90 per cent of Singaporeans live in high-rise apartments and own their own homes.

For a country that gained full independence as recently as 1965, Singapore has come a long way. Legend has it that the island once known as Temasek was settled back in the mists of time by Sri Tri Buana, who established Singapura—the Lion City—after he sighted a leonine beast in the area. His descendants ruled for five generations until the last ruler, Parameswara, was forced to flee when the Javanese attacked. The first documentary evidence for Singapore dates from the thirteenth century, when it was a flourishing centre for trade. A slow decline followed, with jungle reclaiming the island. By the nineteenth century, seafarers who roamed the region had created a few settlements on the island and some enterprising Chinese migrants had established plantations of gambier and pepper. But the arrival of one man would change everything.

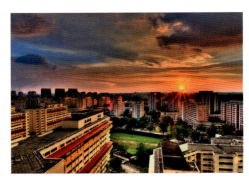

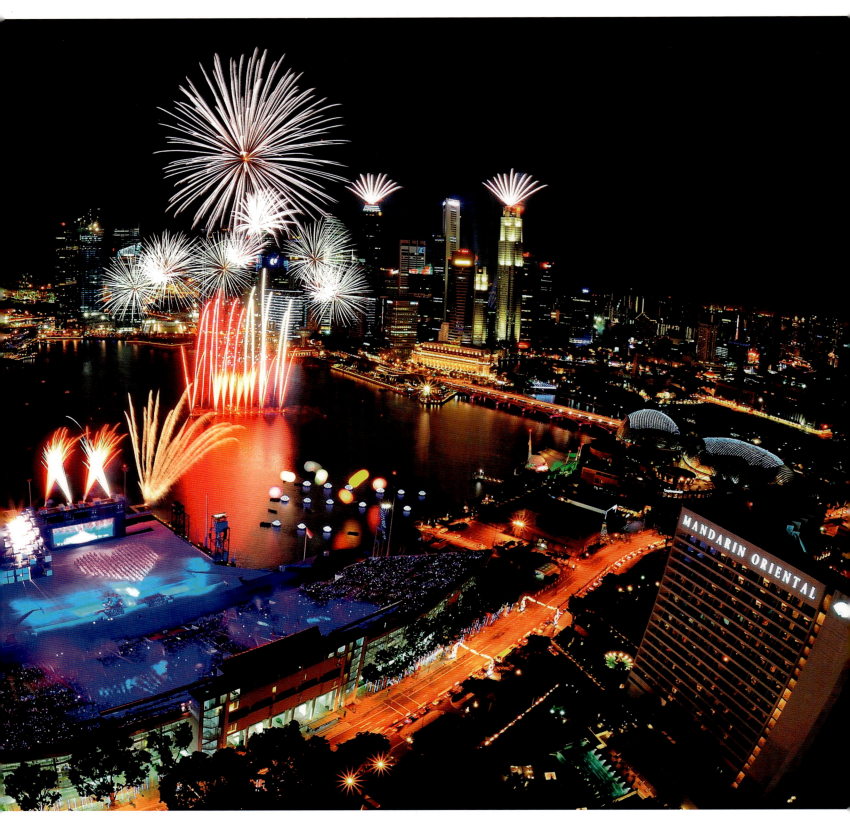

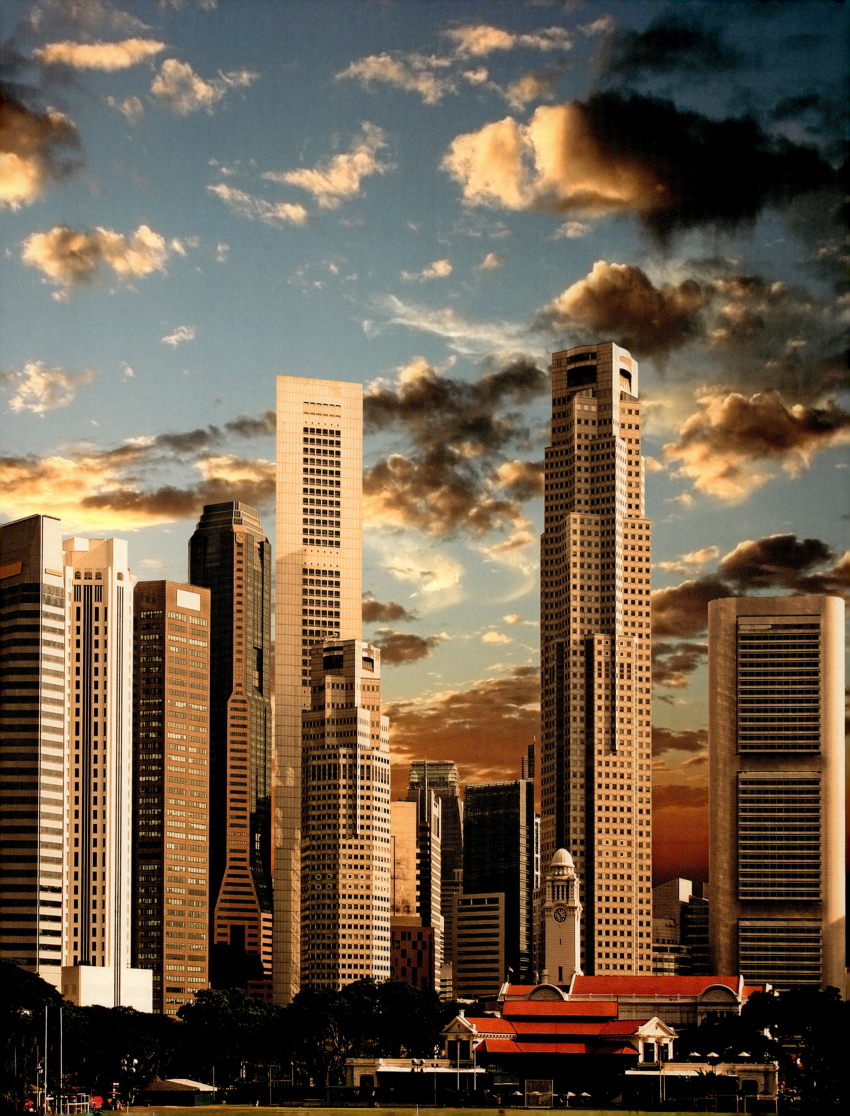

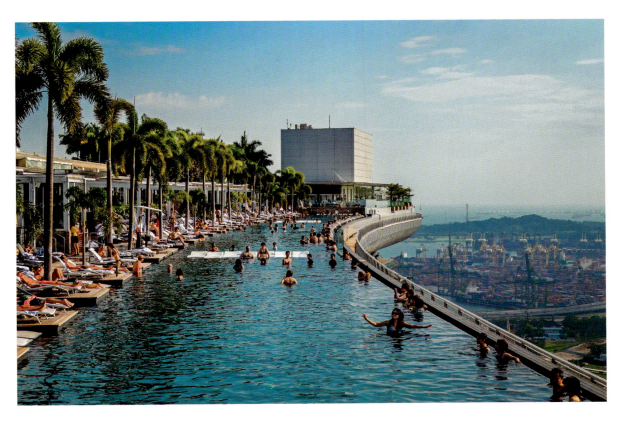

Opposite: Singapore is the region's leading banking and commercial hub.

Left: The infinity pool on the 57th floor at Marina Bay Sands is the highest and largest infinity pool in the world.

Centre left: The Singapore Lions playing against the Indonesia Garudas at Jalan Besar Stadium during the 28th SEA Games.

Below: Chingay is an annual multicultural street parade to celebrate the Chinese New Year and includes performances by local and regional talents.

Bottom left: Buskers in Singapore showcase their skills outside shopping malls, MRT stations and in underground walkways. Some of the more popular buskers have a following on social media.

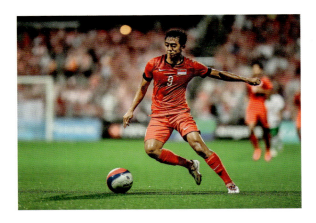

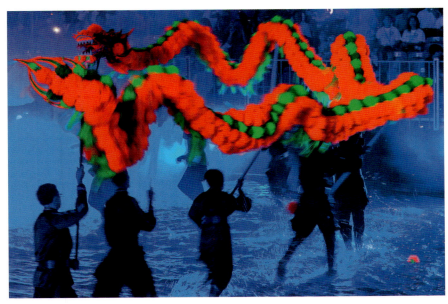

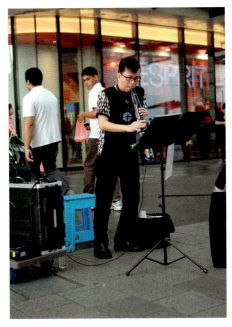

To counter Dutch trading monopolies in the East, Thomas Stamford Raffles signed an agreement with the younger brother of the Sultan of Johor allowing the British to establish a trading post on Singapore and leasing the island in perpetuity for an annual payment of 4,000 silver dollars. Thus began Singapore's modern era. Within three years of Raffles' landing in 1819, the population numbered more than 10,000, of which 60 per cent were Malays. By 1860, at the first census, the population exceeded 80,000 and was mostly Chinese. Other migrants seeking success included Tamils, Ceylonese, Bengalis, Gujuratis, Punjabis, Javanese, Bugis, Balinese and Sumatrans, as well as Europeans. The foundations were laid early on for Singapore's remarkable growth.

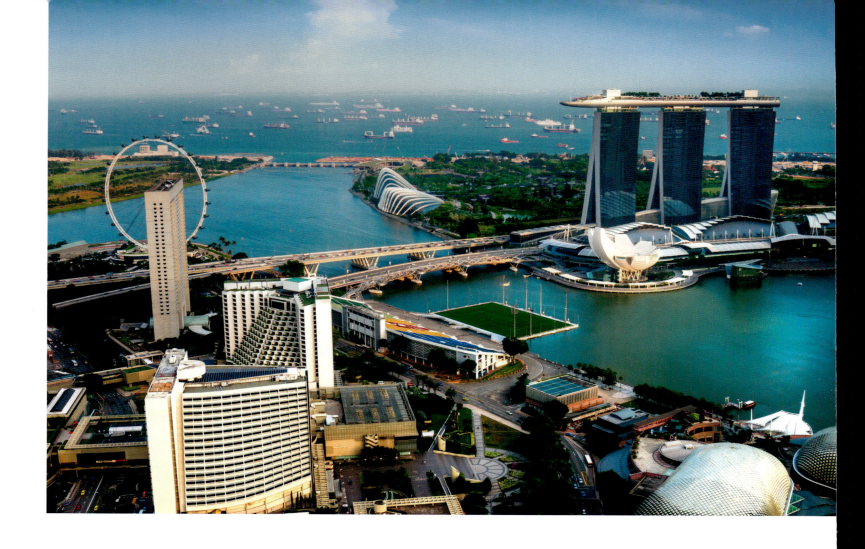

After Raffles, Singapore prospered for many years under the British. In 1929, however, tin and rubber prices collapsed and thousands lost their jobs in the Great Depression. Although considered impregnable by the British, during World War II Singapore was quickly overrun by the Japanese. After peace came in 1945, Singaporeans began planning for independence. Under a new constitution, David Marshall was elected first chief minister in 1955 and he lobbied Britain unsuccessfully for full independence. Meanwhile, a young Straits-born Cambridge graduate led a group of lawyers, teachers and journalists in forming a left-wing political party whose rallying cry was 'Merdeka!' (Freedom). In the 1959 elections, Lee Kuan Yew and his People's Action Party swept to power. After failing to become part of Malaysia in 1963, Singapore became fully independent in 1965. Lee became the first prime minister and stayed in that position for 31 years, stepping aside in 1990 to allow a younger generation to take the political reins. His vision, intellect and integrity have earned him a place in history. With his passing in 2015, Singapore entered a new era.

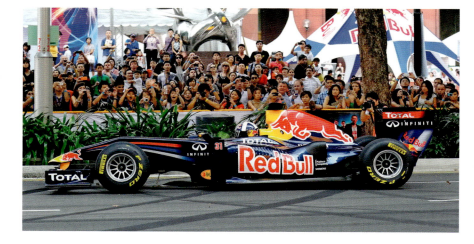

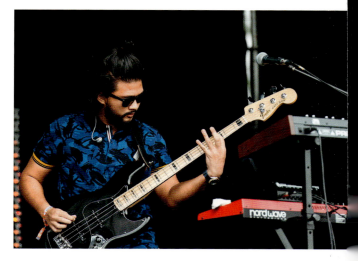

**Top:** The Marina Bay area comprises not only the financial district but also dining and shopping options, hotels and attractions like the Singapore Flyer and Gardens By the Bay.
**Above:** Former Red Bull driver David Coulthard displays his driving prowess in an hour-long stunt showcase at Orchard Road to generate interest in the Formula 1 Grand Prix.
**Right:** Music festivals such as St Jerome's Laneway have been held in Singapore, featuring international and local music acts like Enterprise (pictured).

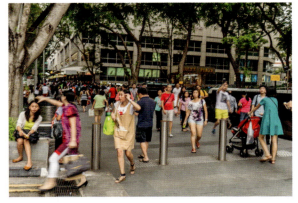

**Far left:** Siloso Beach on Sentosa Island is a popular weekend getaway.
**Left:** Orchard Road has more than 5,000 dining and shopping outlets.
**Below:** The newly refurbished Victoria Theatre and Concert Hall has been gazetted as a National Monument and is home to the Singapore Symphony Orchestra.
**Bottom:** Singapore's tallest skyscrapers are capped at 280 metres because of their proximity to Paya Lebar Airbase.

Post-colonial Singapore is an astonishing success story. The People's Action Party, in power to this day, began alleviating poverty early. Infrastructure has always been a high priority. Low-cost, high-rise housing replaced overcrowded downtown areas, and most Singaporeans now own their homes. The container port is one of the world's busiest and most efficient. The Mass Rapid Transit system is the envy of other nations. Business travellers consistently rate Changi Airport the best in the world. Manufacturing industries fuelled much of the initial growth for many years, aided by the famous Singaporean work ethic. Tourism, too, has been encouraged and is a thriving industry, as has the banking and financial sector.

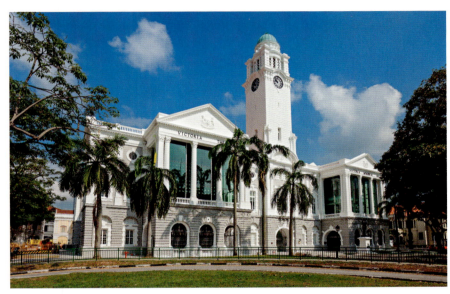

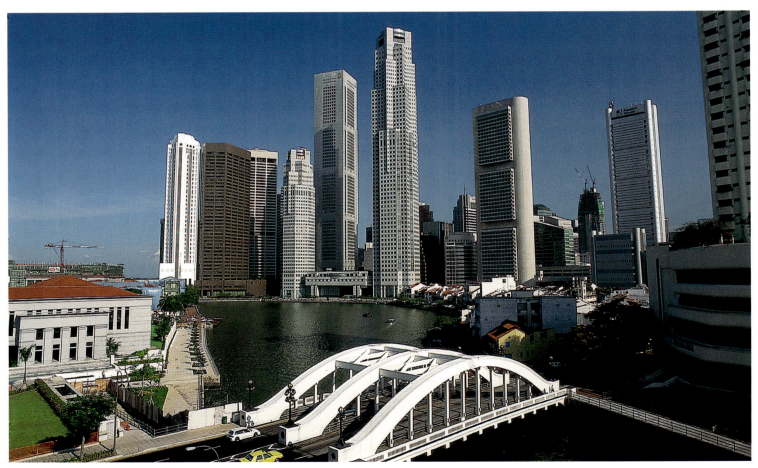

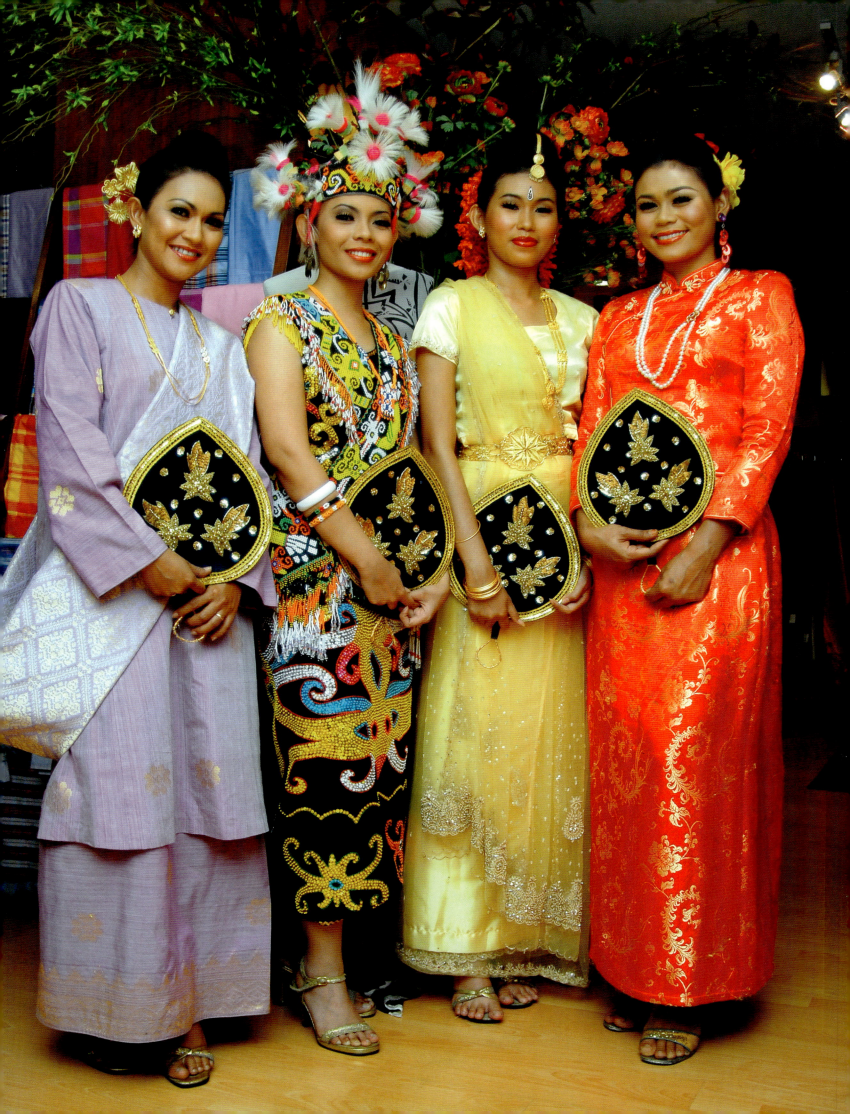

# The Dynamic Melting Pot of Asia

**Since the 1970s, Singapore has been a peaceful, multicultural society composed of ethnic Chinese, Malays, Indians, Eurasians and others.**

**Left:** The costumes of Singapore's multicultural population include sarongs and shoulder cloths, bright colours and intricate beadwork. Many borrow elements from each other's costumes.

**Right:** Participants at the River Hongbao celebration at The Float@Marina Bay usher in the Lunar New Year.

**Below left:** The crew working at the St Jerome's Laneway Festival in Singapore.

**Below right:** Once a mainstay of public transport, trishaws are now largely popular with tourists. Trishaw tours around Singapore can be arranged from Trishaw Uncle.

Who are the Singaporeans? Early in the nineteenth century, Malays formed the majority of Singapore's population. Now the balance has shifted and Singaporean Chinese are in the majority. They form 78 per cent of the population, followed by Malays (15 per cent) and Indians (7 per cent), with Eurasians, Westerners and others making up the balance. You can hear people speaking Hokkien, Mandarin, Cantonese, Teochew, Malay (still the official national tongue and the language of the national anthem), Tamil, Hindi, Portuguese and English—not to mention Singlish, the local dialect, a mix of all the above languages. Some Singlish words have recently been added to the *Oxford English Dictionary*. Such diversity makes for a fascinating blend of cultures.

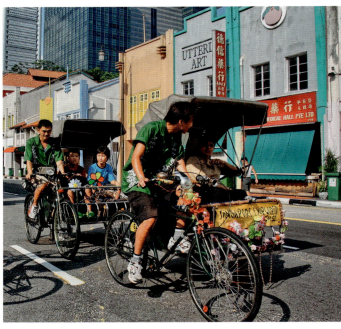

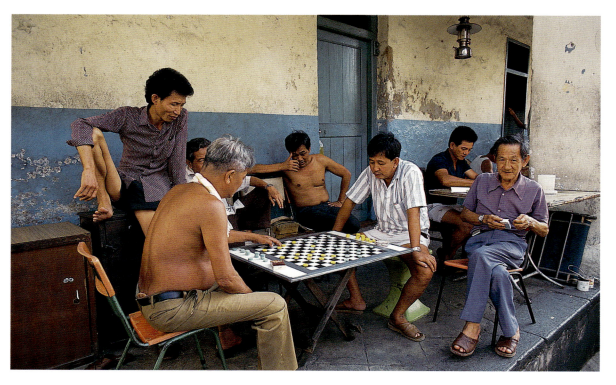

**Left:** Near Serangoon Road, Chinese chess players battle it out on a five-foot way, as the covered sidewalks are still generally called in Singapore.
**Below:** The ambition of these Muslim boys will be to earn the right to wear the white head-wear as adults that indicates they are Haji, men who have undertaken the all-important pilgrimage to Mecca.
**Below left:** These Peranakan women are wearing the tradi-tional *sarung kebaya* (Malay for sarong and embroidered blouse). The Peranakan are ethnic Chinese whose culture and language are influenced by the Malays.
**Bottom:** Family is everything in Singapore, where ties between members are still exceptionally strong.

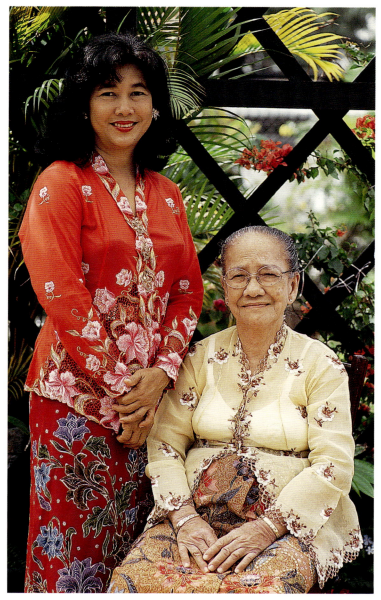

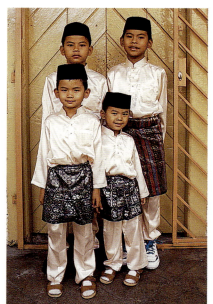

**Above:** A free night-time outdoor concert at Esplanade–Theatres on the Bay, where performances range from classical music to rock concerts.

**Right:** Happy participants in the annual Chingay parade, which takes place during Chinese New Year.

**Far right:** Performers from the group Pastel Lite at the St Jerome Laneway Festival. The festival now travels to seven different cities.

**Below:** Hindus give thanks for prayers answered during the Thaipusam festival. They live cleanly and pierce their cheeks and other parts of the body with iron needles. This is followed by a pilgrimage to the temple while carrying *kavadi*, heavy structures whose weight is transferred to the carrier by steel skewers piercing the penitent's flesh.

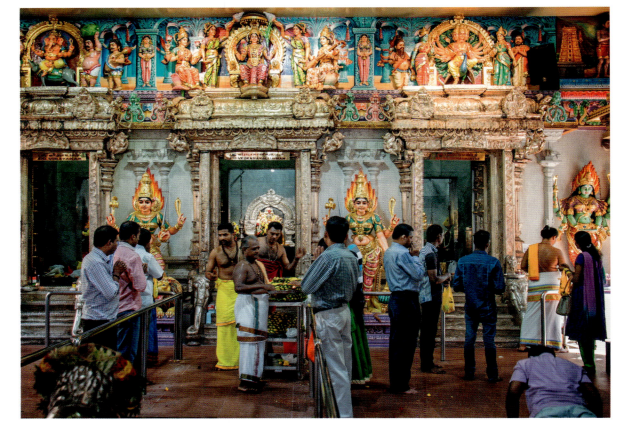

# Singapore's Rich Colonial Heritage

**Singapore has preserved many iconic buildings from its colonial past.**

**Left:** A bust of Sir Thomas Stamford Raffles, the founder of Singapore. Many reminders of him can be found around the island, visible in images and in the use of his name.

**Below:** Raffles Hotel was previously a boarding house for Raffles Institution, an old and prestigious secondary school. It is also the birthplace of a famous local cocktail, the Singapore Sling.

**Bottom left:** The National Gallery's special exhibition, 'After the Rain', is a collection of works by artist Chua Ek Kay.

**Bottom right:** Raffles Hotel, with its gleaming marble colonnades, is one of the finest examples of colonial architecture. Pictured here in the hotel's lobby.

**Opposite above:** The Asian Civilisations Museum, established in 1997, faces the Singapore River and houses exhibitions featuring the material history of Singapore and ancestral homes from around Asia.

**Opposite below:** Previously the Convent of the Holy Infant Jesus, now known as CHIJMES, the buildings around the chapel have been transformed into restaurants and shops. The church is used for weddings and other private events.

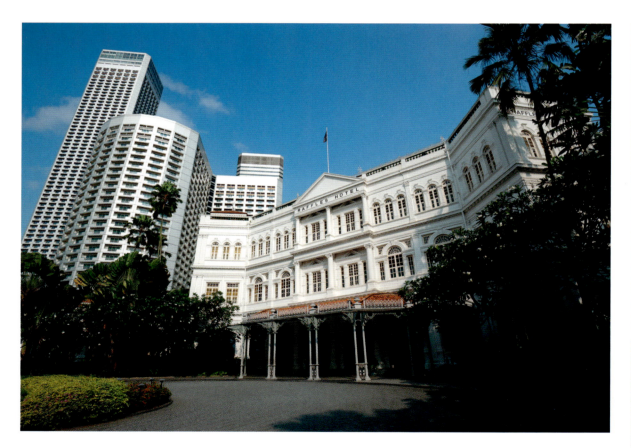

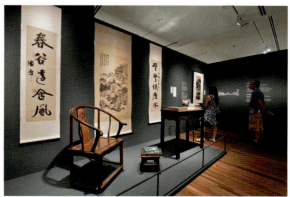

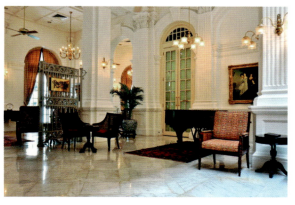

The colonial history of Singapore began in 1819 when Raffles landed. Many early buildings were designed by the Irish architect George Coleman, who consulted with Raffles on the Town Plan of 1822–3. Several of his buildings remain, including the charming Armenian Church. Another great architect of the colonial period was the Englishman Alfred John Bidwell, whose work included the original main wing of the Raffles Hotel, the Goodwood Hotel, Stamford House, Singapore Cricket Club and Victoria Theatre. Between them, these two men created the finest colonial architecture in the region. The Padang, or town square, is the centre for several fine buildings, including the Cricket Club, Supreme Court, City Hall, old Parliament House (now the newly renovated and reopened National Gallery) and Victoria Theatre. Many historic buildings were lost, however, in the race for economic prosperity after independence.

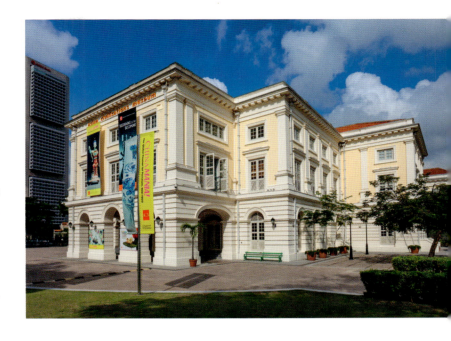

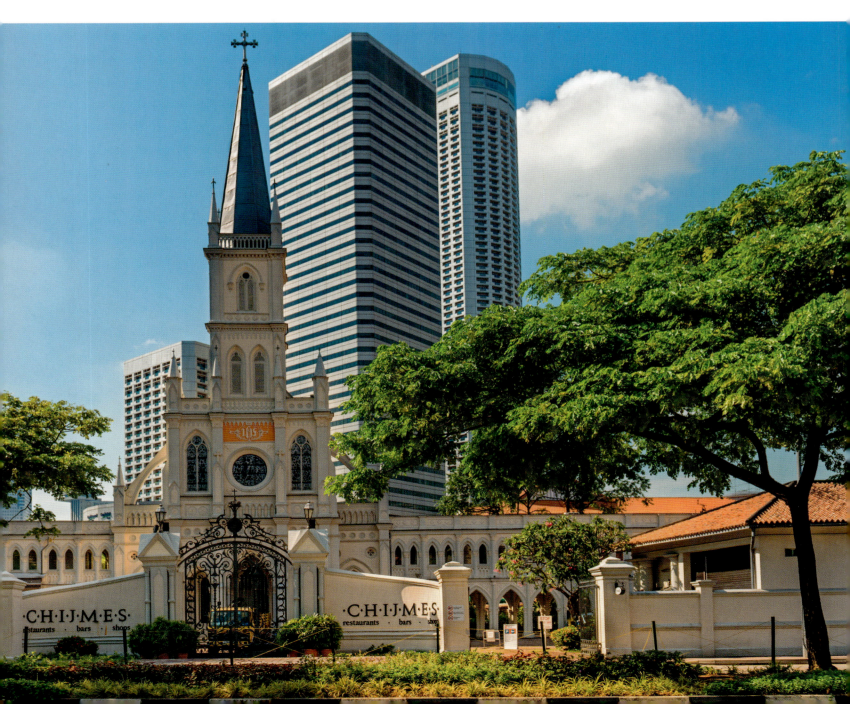

Whole neighbourhoods were destroyed, although critics should recall that many of the buildings torn down were cramped and waterlogged. Conservation efforts began in 1970 with the passing of the Preservation of Monuments Act, followed in 1973 by the Urban Redevelopment Act. While Bugis Street (which was moved 300 metres!) and Little India have been criticized, preservation work at Boat Quay, the former St Joseph's Institution (now the Singapore Art Museum), Empress Place and elsewhere has been highly praised.

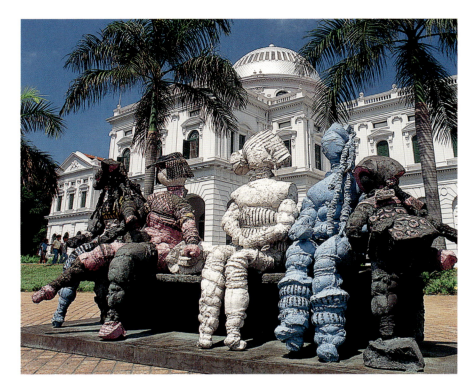

**Right:** The 'Living World' by Taiwanese sculptor Ju Ming is a permanent exhibit outside the National Museum of Singapore.
**Below:** The Old Hill Street Police Station was built in 1934 in the Neoclassical style. It now houses several government ministries, including the Ministry of Communications and Information and the Ministry of Culture, Community and Youth.
**Opposite top left:** A 6-metre cast-iron fountain is the focal point of the Palm Garden in front of the Raffles Hotel.

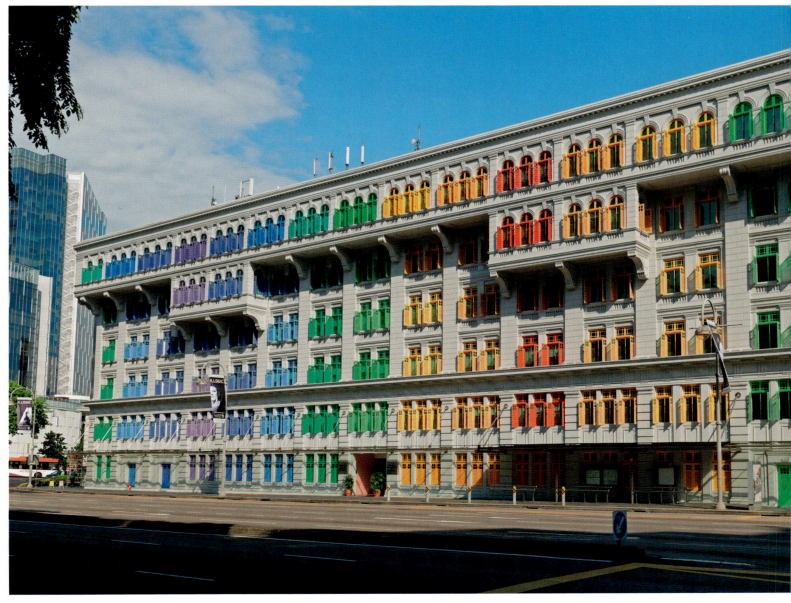

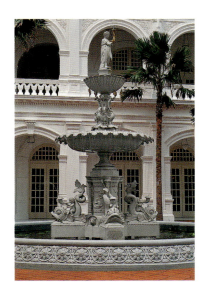

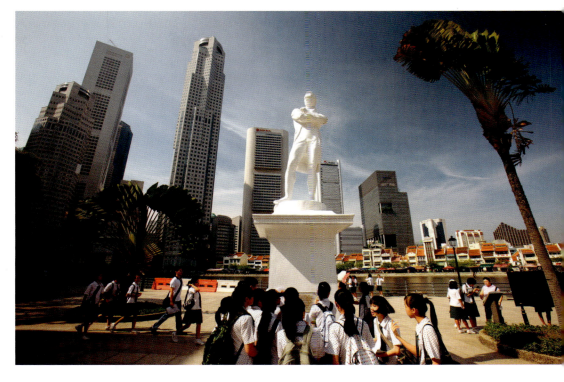

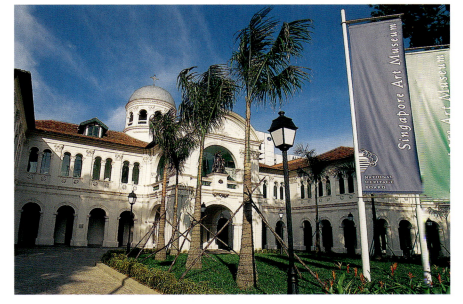

**Above:** Students cluster around the white polymarble statue of Sir Stamford Raffles at the Raffles Landing Site. The original statue, nicknamed 'Iron Man', was cast in bronze and is now in front of the Victoria Concert Hall.

**Left:** The Singapore Art Museum, rehoused in the restored nineteenth-century St Joseph's Institution, opened its doors in 1996.

**Below left:** The Sikh doorman at the Raffles Hotel is one of the most photographed people in Singapore.

**Below:** One of the windows of the Tan Teng Niah Residence, an eight-room multicoloured villa that mixes Peranakan and European influences in its design.

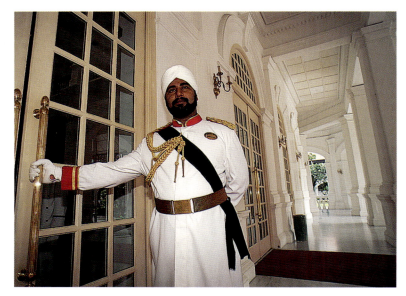

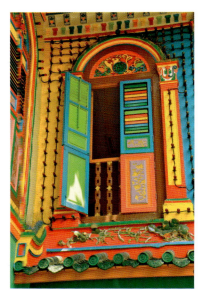

# Marina Bay and the Financial District

**Towering over a landscape studded with skyscrapers, the financial heart of Singapore also has pockets of greenery and many outstanding attractions.**

**Right:** The southern part of the Downtown Core, which includes the commercial buildings at Shenton Way and Raffles Place, covers an area of about 266 hectares. It is one of the most densely populated areas in Singapore. All the buildings sit upon man-made landfill which, over the past century, has increased Singapore's total land area by close to 25 per cent.
**Below:** Much of this skyline has been added in recent years, first the Esplanade (far left), nicknamed the 'Durian' by locals, followed by the Singapore Flyer and the Marina Bay Sands (right side).

Business makes Singapore tick. Much of it was originally carried out by foreign multinational companies. Many are American, but others come from Great Britain, Germany, France, Australia, Japan, South Korea and other countries. Overseas companies have brought in skilled foreign workers. Many Singaporean families employ foreign maids, since both parents work, and construction workers from overseas are contracted to maintain the roads and the infrastructure.

About 780,300 foreign workers (excluding construction and domestic workers) have been added to Singapore's population of about 5.6 million, another marker of this tiny country's prosperity. Initially, the main industry was manufacturing, followed by the electronics sector. Singaporeans today tend to be well educated, with many gaining degrees overseas and returning home to good jobs. Information technology, biotechnology, finance and other service industries like advertising have become important sectors as well. The statistics are impressive. Singapore has a per capita annual income in excess of US$38,000 (as of 2014), one of the world's highest. It has no foreign debt; indeed, it has reserves of about US$163 billion from Temasek Holdings and about US$247 billion in foreign reserves (as of 2015). This is an impressive achievement for a small island with no natural resources!

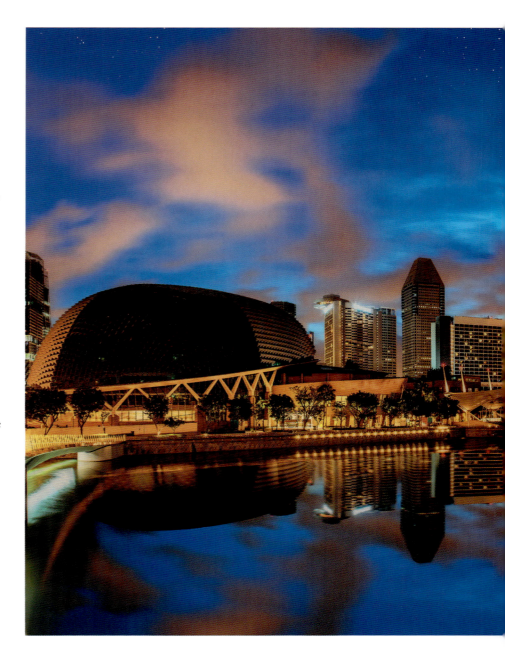

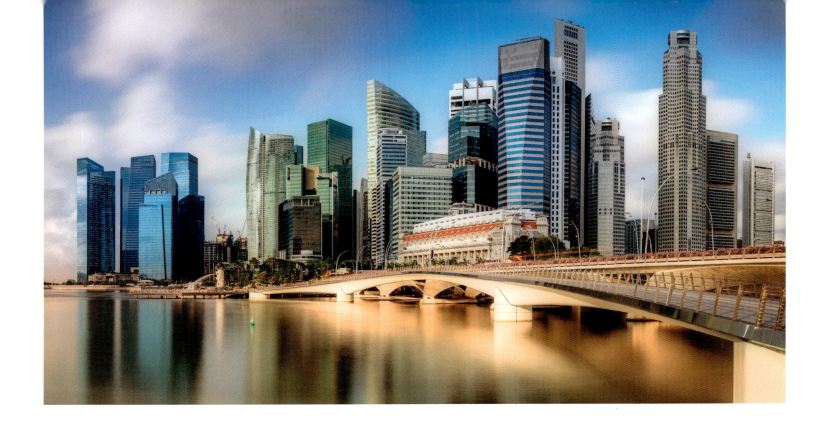

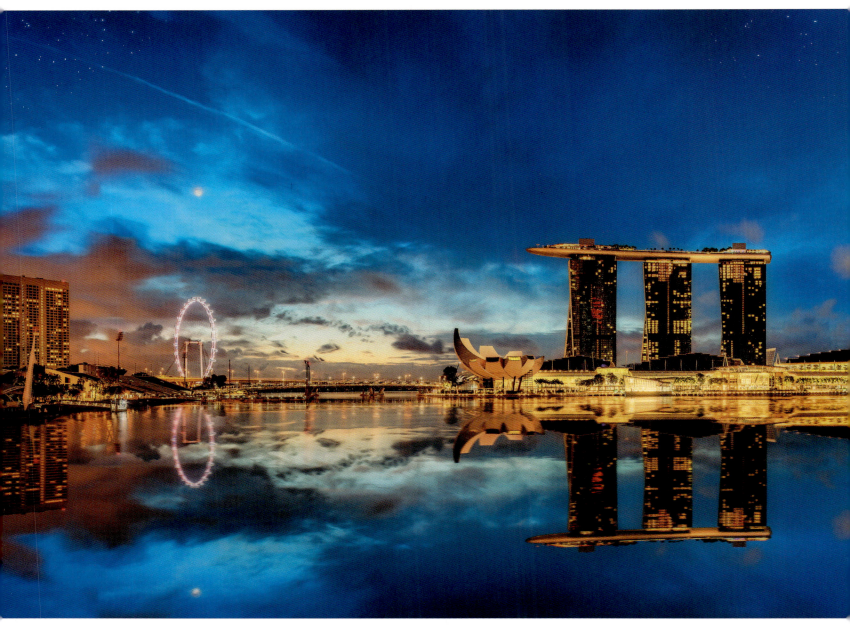

There is generally a low unemployment rate. Most working citizens must contribute, along with their employer, towards their own retirement fund, called the Central Provident Fund. The CPF is also used to make mortgage payments, pay for hospitalization and cover certain other important expenses, such as further education.

Much of the banking and finance companies can be found in the downtown area spanning Newton, Orchard, Outram, Rochor to the main area of Tanjong Pagar to Raffles Place and now the Marina Bay area—known commonly as the Central Business District (or colloquially, the CBD; Singaporeans do love their abbreviations).

**Above:** Another great location to enjoy a free concert is inside the concourse of the Esplanade, where local and foreign performers take the stage.
**Top right:** Several running events take place annually in Singapore, one of them the Colour Run, possibly the most fun. Runners get sprayed with coloured powder as they make their way along the 5-kilometre route.
**Above right and right:** Gaily attired sales girls pass out leaflets in Raffles Place. With its high volume of office workers, it is often the location for sales promotions.

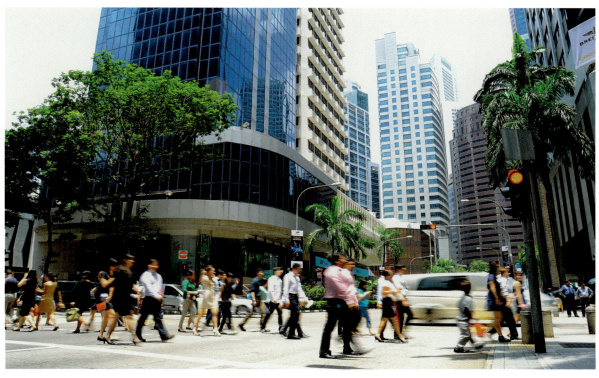

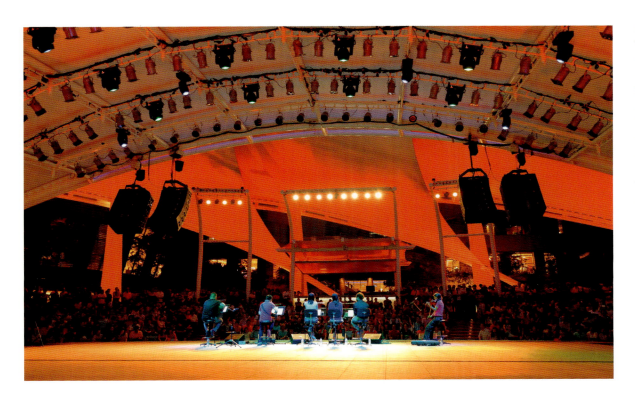

**Left:** The Esplanade Outdoor Theatre can seat up to 450 people and usually hosts performances during the weekends.
**Below:** Located at Marina Bay Sands, the Louis Vuitton Island Maison designer clothing store is a nautical-inspired stand-alone glass and steel pavilion. Opened in 2011, it is the first Maison concept store in Southeast Asia and the twelfth in the world.

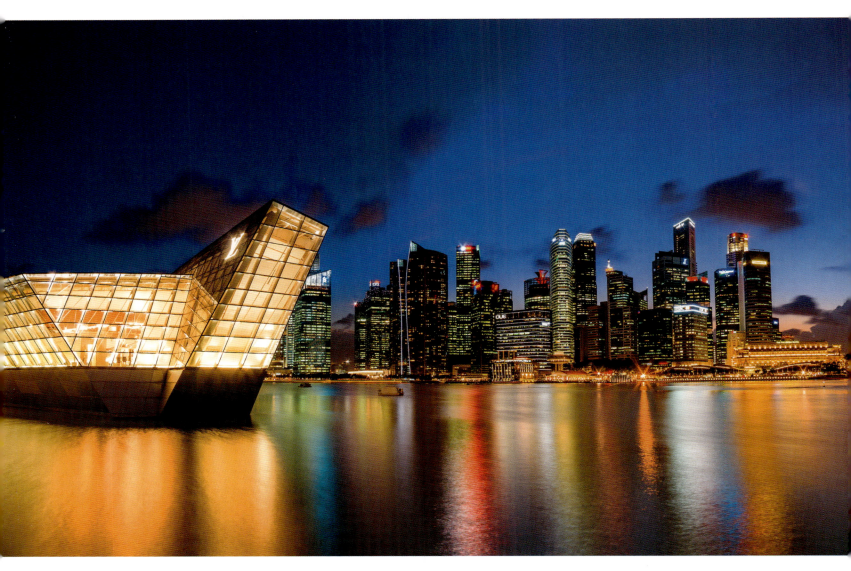

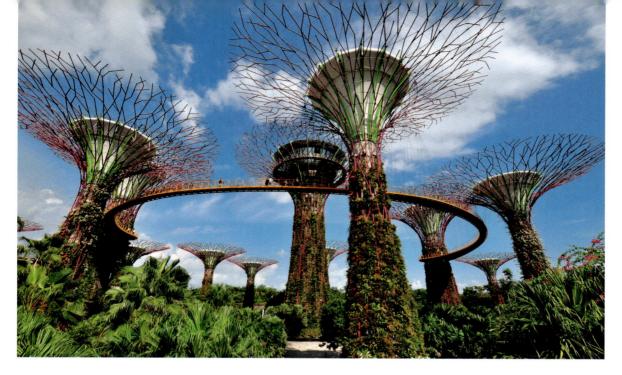

**Above:** Eighteen imposing 50-metre artificial, solar-powered Supertrees tower over the Gardens by the Bay, twelve of them in Supertree Grove. For the best views of the garden and the Marina Bay Financial District, stroll along the 128-metre OCBC Skyway, suspended 22 metres above the ground.

**Right:** The walkway down from the Cloud Forest to the Flower Dome has been featured in the film *Hitman: Agent 47*. The Cloud Forest showcases plants that live in climates up to 2,000 metres above sea level, while the 35-metre mountain boasts the world's tallest indoor waterfall.

**Below:** The World of Plants comprises six different gardens examining the different parts of the plant.

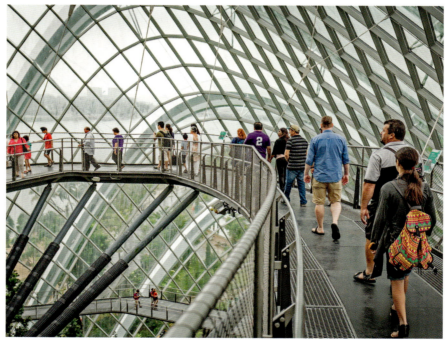

The district, marked by gleaming skyscrapers, includes the three tallest buildings in the city—the United Overseas Bank Plaza One, the Republic Plaza and the Overseas Union Bank Centre. Since 2000, more skyscrapers have been added, such as the Marina Bay Financial Centre and the Ocean Financial Centre.

Occupying 101 hectares of prime land in Marina Bay, the latest green addition to the country is the Gardens by the Bay, featuring the Flower Dome and Cloud Forest cooled conservatories, eighteen Supertrees—one of the most photographed sights of the gardens—and the Heritage Gardens. It has welcomed more than 20 million visitors since its opening in 2012.

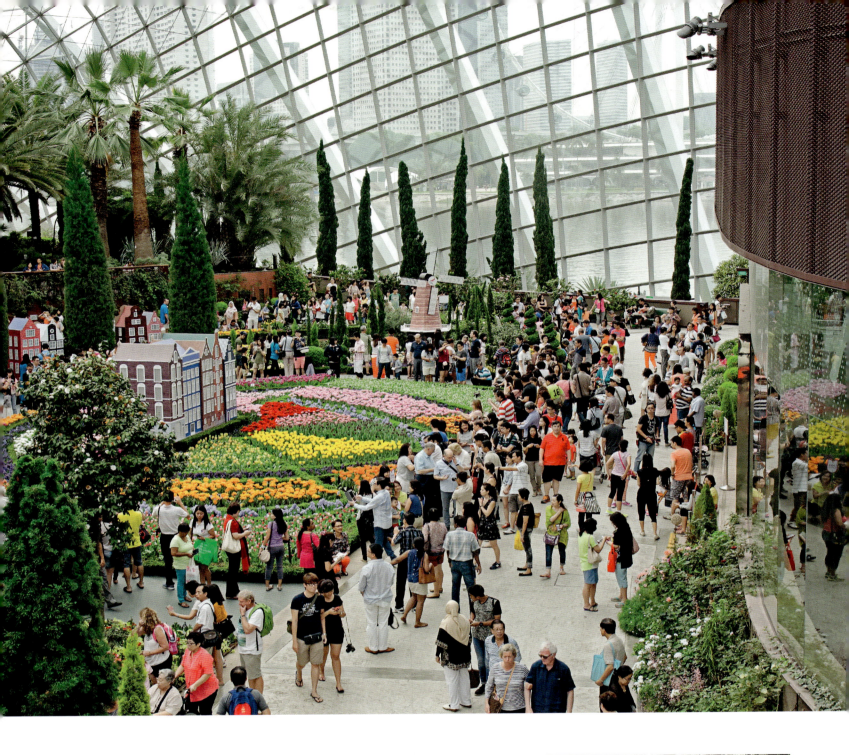

**Above:** The 1.2-hectare Flower Dome features ever-changing exhibits, such as this Netherlands-inspired tulip garden in April and May. Other floral displays include cherry blossoms in March and lilies in June and July.

**Right:** The Venus flytraps and Rafflesia pictured here in the 0.8-hectare Cloud Forest are completely made out of LEGO® bricks. The Gardens also has more than 40 sculptures from around the world, such as the Floral Clock and the Giant Snail, which sits in the Secret Garden of the Cloud Forest.

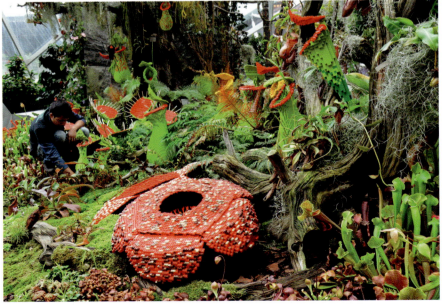

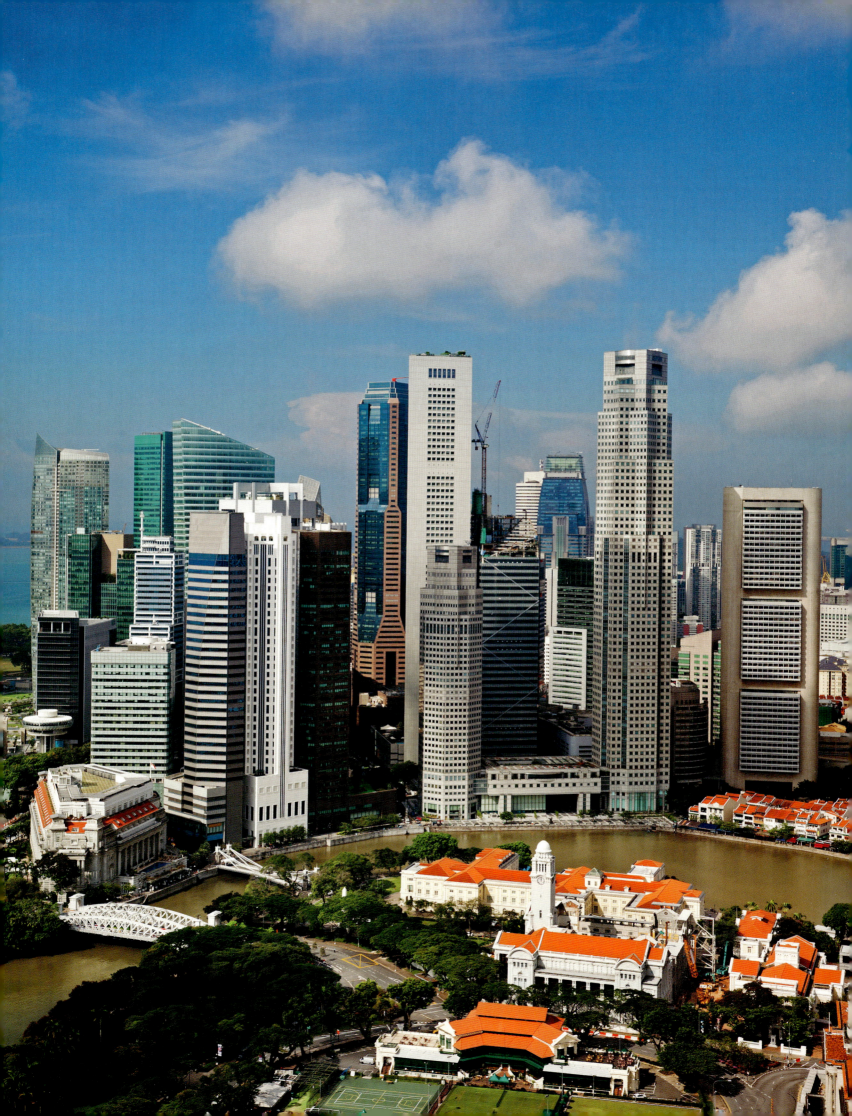

# Exploring the Singapore River

**The Singapore River has witnessed many important events in the country's history. It is a fascinating starting point for your exploration of the city.**

Decaying human skulls, apparently left by roving Malay pirates, littered the banks of the Singapore River when Raffles and company stepped ashore on 29 January 1819. Later, the river saw wave after wave of immigrant labourers arrive from China, India, Europe and elsewhere. For many years, the river was the main gateway into the city for goods and people who arrived by sea. Merchants became wealthy and built business premises with homes above them, called shophouses, along its banks.

The river went into decline after a deepwater port was developed elsewhere, with only small craft, such as

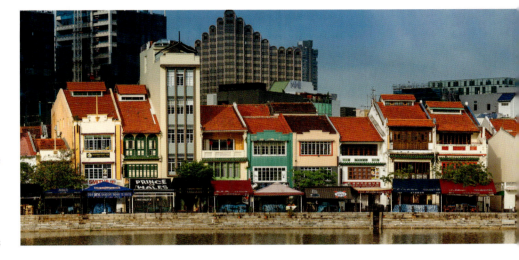

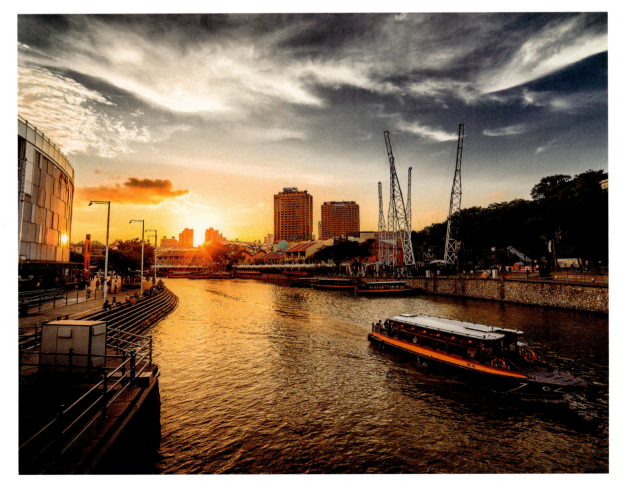

**Opposite:** Singapore's earliest settlements were in this area, on the banks of the Singapore River. Today, skyscrapers dominate the city, while the preserved heritage buildings have been repurposed as museums or dining and entertainment venues.

**Above:** The shophouses around Boat Quay have been carefully preserved and are now home to restaurants, bars and pubs. The tenants also include a budget hotel and a cat cafe.

**Left:** Aside from taking a leisurely bumboat cruise down the Singapore River, tourists can also try extreme rides like the G-Max Reverse Bungy and the GX-5 Extreme Swing, which falls from 50 metres at a speed of 120 kilometres per hour.

*twakow*, or bumboats, in use until 1983. Now, over 160 years after Raffles left Singapore (he died of a brain tumour three years later in London at the age of 44), the river has been totally transformed and the shophouses converted to bars, restaurants and shops. Boat Quay was the first area to undergo a major renovation, and neighbouring Clarke Quay and Robertson Quay soon followed suit. For visitors and locals alike, the river is now the hub of a vibrant social scene. On Singapore's balmy tropical evenings, nothing is more pleasant than wining and dining with friends beside the river.

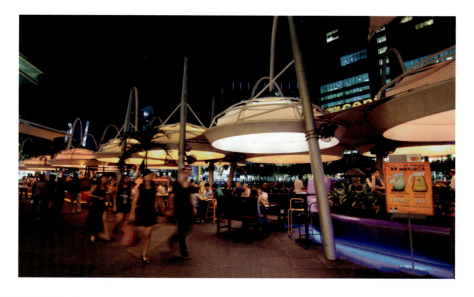

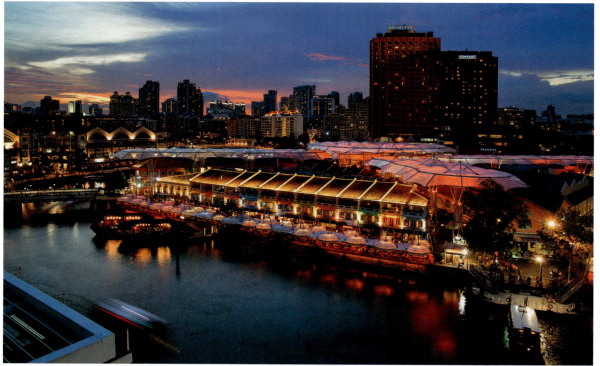

**Above and left:** A multitude of dining and nightlife options can be found along Boat Quay, Clarke Quay and Robertson Quay, with bars, pubs and restaurants aplenty.
**Below left:** The 'First Generation' sculpture by Chong Fah Cheong at Cavenagh Bridge depicts scenes from yesteryear, where children would jump naked into the river for a swim.
**Below:** The bumboats that have plied the Singapore River for more than a century now ferry tourists on electricity rather than diesel.
**Right:** The polymarble statue of Sir Stamford Raffles marks the place where he first landed on Singapore's shores in 1819 to found a small trading post.

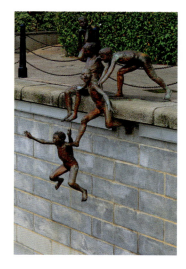

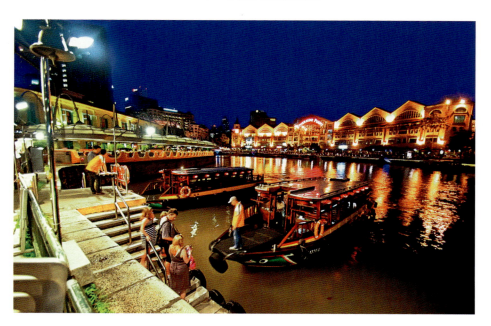

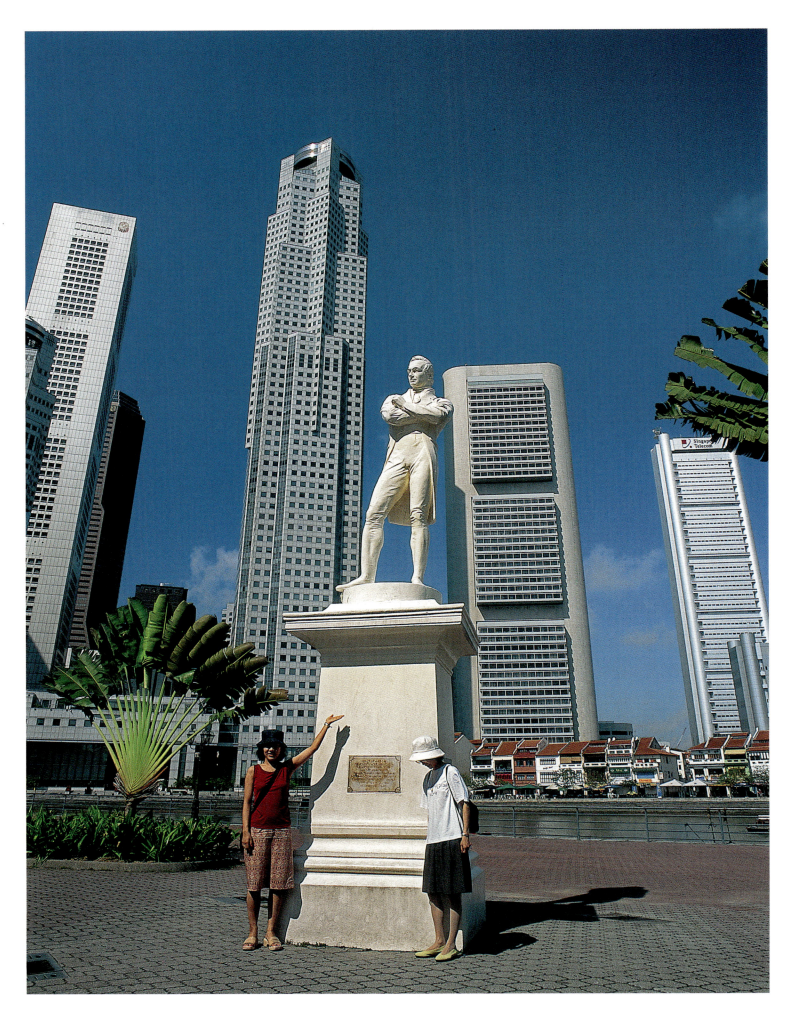

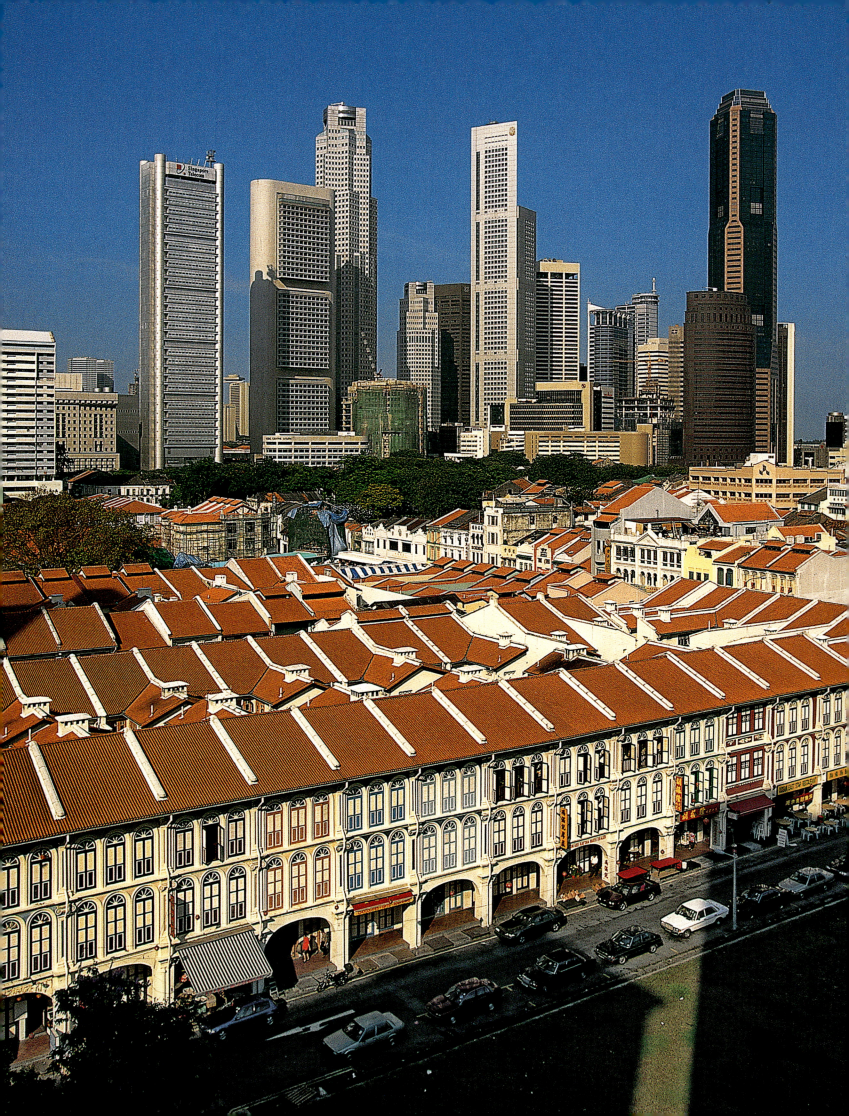

**Left:** The elegant old shophouses of Chinatown include local design elements—Malay timber fretwork, Chinese porcelain chip friezes and bold paintwork.
**Right:** Trengganu Street becomes a pedestrian shopping street and night market after dark.
**Below left:** Shops in Chinatown are a great place to pick up affordable souvenirs, toys and collectibles.
**Below right:** An elderly man plays the *erhu* while dressed in a *samfu* and a hat with pigtails. This style of dress originated during the Qing Dynasty and was popular in Singapore in the nineteenth century.

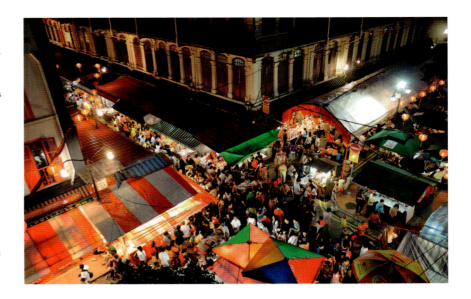

# The Traditional Charms of Chinatown

Chinatown was established by early immigrants who came ashore from cramped junks after a long, hard journey from China, with only the shirts on their backs.

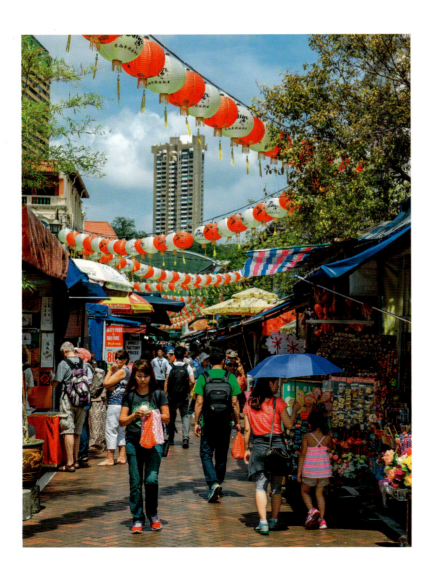

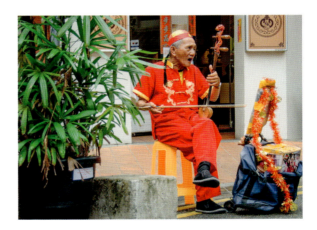

Today, these early Chinese immigrants would recognize almost nothing of the Chinatown that greeted them in the nineteenth century. Stepping ashore after sailing in junks from China, they settled in a couple of square kilometres just south of the river. They worked as indentured labourers in harbourside warehouses or on rubber plantations until they paid off the cost of their passage. Some later became hawkers, tailors or jewellery makers, industries that still survive in Chinatown. At Thian Hock Keng temple, the Temple of Heavenly Happiness, the Hokkien immigrants gave thanks for a safe journey. The present temple was built on the site of the original one in 1840,

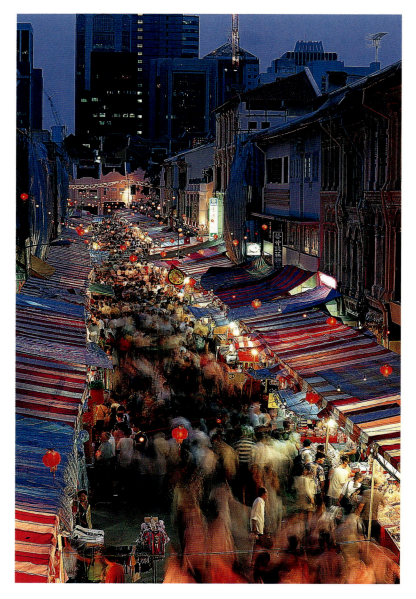

and is itself being extensively renovated. That's the story of Chinatown, where entire streets are now restored or rebuilt. Miraculously, the area still has an old world atmosphere worth savouring and enough historical buildings to make it fascinating. Unless a sign says Fixed Price, you can bargain for the price of goods on sale in the crowded, noisy streets. You can also see fortune tellers, medicine men, calligraphers and temple mediums, and peek into a Chinese medicine hall or a shop selling paper money, cars and houses that are burned to send off to deceased relatives. Many curious aromas waft along the sidewalks. In the midst of all this, as if to flout the spirit of Raffles, who in his City Plan divided the city's quarters along ethnic lines, are mosques and Hindu temples, including the Sri Mariamman Temple on South Bridge Road where a fire-walking ceremony called Thimithi takes place each year.

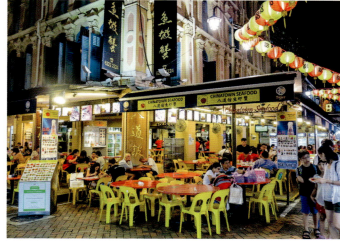

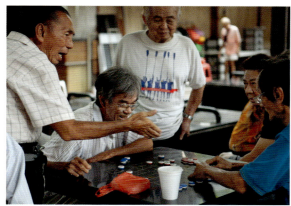

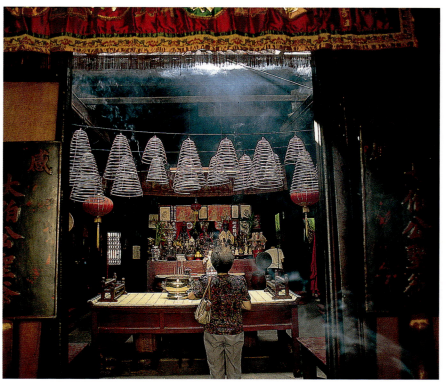

**Top left:** People flock to Chinatown to buy goodies and decorations in preparation for the 15-day Chinese New Year celebrations, usually held in January or February each year. The actual dates follow the Lunar calendar.

**Top right:** Enjoy some local Chinese dishes and a Tiger beer at the Chinatown Seafood Restaurant on Trengganu Street.
**Above:** Elderly Singaporeans play a game of Chinese chess on tables set outside.
**Right:** Praying in a Chinese temple dedicated to the deity Tua Pek Gong.

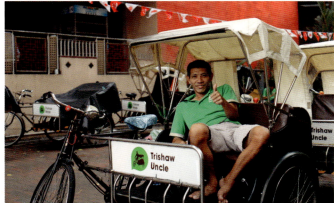

**Left:** Trishaw Uncle is a tour company whose drivers take travellers around Singapore via trishaw. These trishaws are outfitted with radios under the seats.
**Below left:** The famed Buddha Tooth Relic temple (the relic is located on the fourth floor) encased in a stupa made of 320 kg of pure gold.

**Below:** NUS Baba House is a pre-war terrace house once owned by a nineteenth-century shipping tycoon. Now converted into a museum, it gives visitors a glimpse of the lavish homes and lifestyles of the Peranakan in the 1920s.
**Bottom:** A Chinese calligrapher at work.

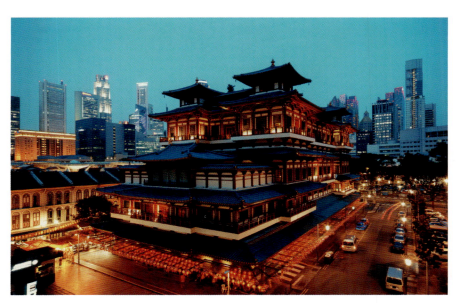

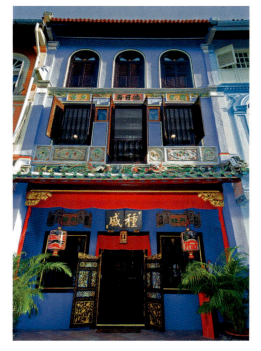

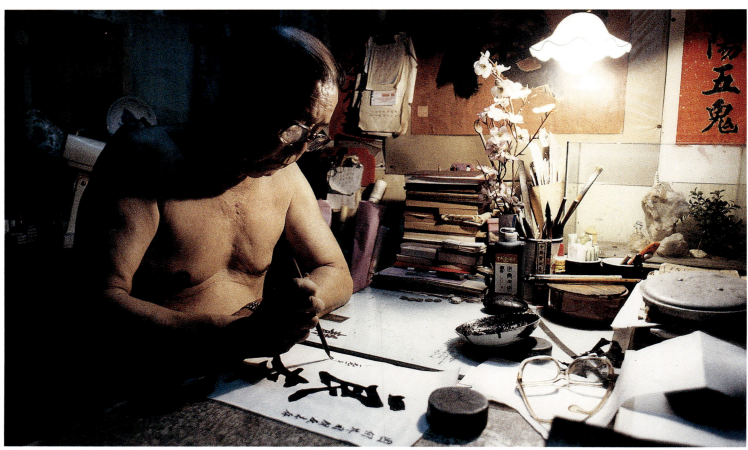

# Orchard Road—A Shoppers' Paradise

Once a quiet country lane with nutmeg and pepper orchards, this is now one of Asia's most famous shopping boulevards.

**Left:** The menswear section of Takashimaya department store.
**Right:** Wheelock Place was designed by Kisho Kurokawa and was completed in 1994. Apart from shops and restaurants, it has a number of medical clinics.
**Below right:** The award-winning ION Orchard mall has an observation deck on its 55th and 56th floors, providing panoramic views of Orchard Road.

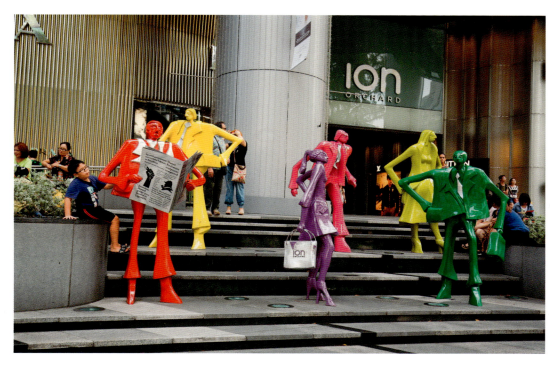

**Above:** These colourful aluminium sculptures were designed by Swiss sculptor Kurt Laurenz Metzler.
**Right:** The five-storey Gucci flagship store in Paragon Shopping Centre in Orchard Road. Other designer brands with sidewalk storefronts include Miu Miu, Prada, Tod's and Salvatore Ferragamo.

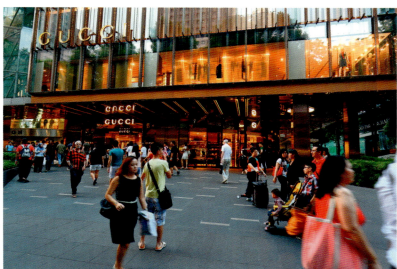

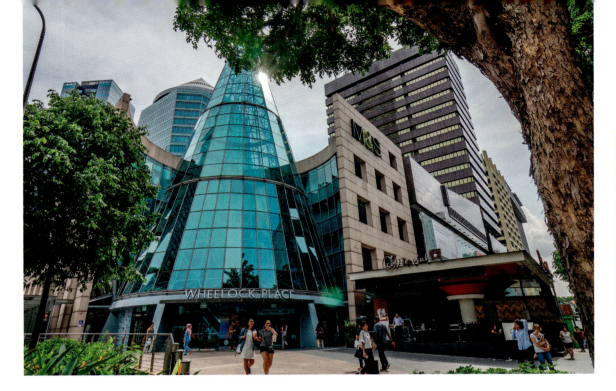

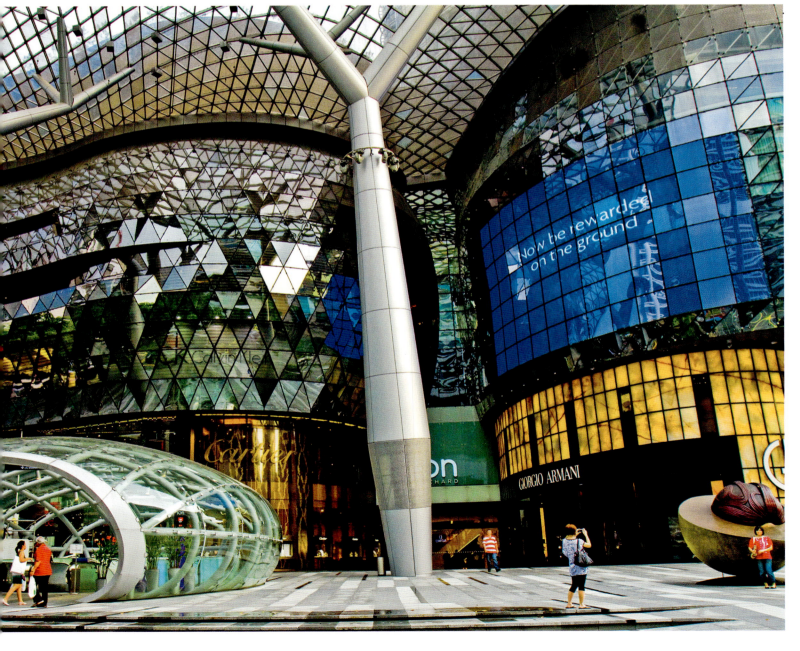

**Right:** The largest H&M store in Southeast Asia, spanning about four floors.

**Below right:** Sidewalk cafes are quite popular, found outside Emerald Hill, 313@ Somerset and around the Scotts Road intersection.

**Bottom left and right:** Tourists and locals mingle on the broad sidewalks outside Ngee Ann City, fondly known as 'Taka' for its iconic department store, Takashimaya.

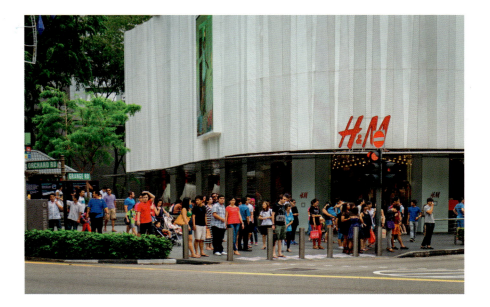

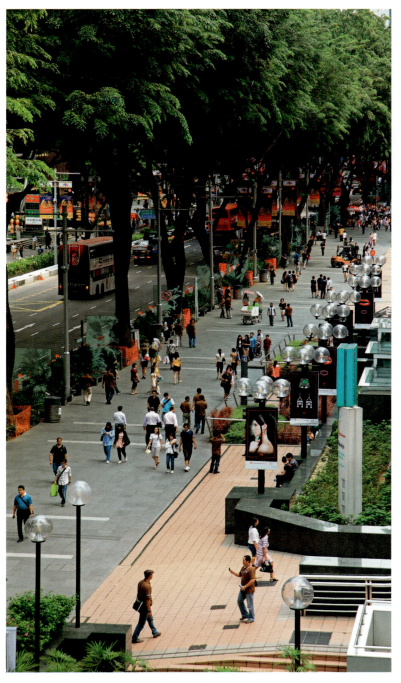

Today, everyone associates Orchard Road with shopping, but within living memory it was little more than a quiet country lane, complete with tigers. Big changes began in 1958 when Tang Choon Keng moved his C. K. Tang store here from River Valley Road. Now, just as on New York's Fifth Avenue and London's Bond Street, you can see the world's top brand names in shopping centres like ION Orchard, 313@Somerset, Mandarin Gallery, Wisma Atria, The Heeren and Ngee Ann City. Orchard Road is now one of Asia's top addresses for shopping and people watching.

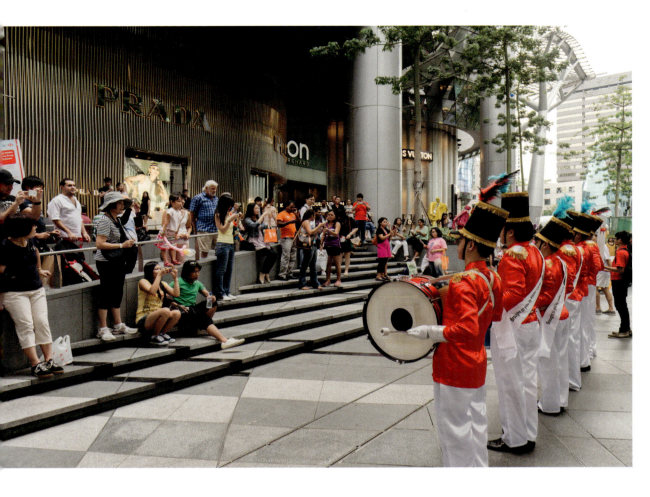

**Left:** Pedestrians strolling down Orchard Road are likely to encounter buskers and musical performances, such as this one outside ION Orchard.
**Below:** Mandarin Gallery, which is attached to the Mandarin Orchard Hotel, boasts luxury designer brands like Paul Smith, Mulberry and Bell & Ross.

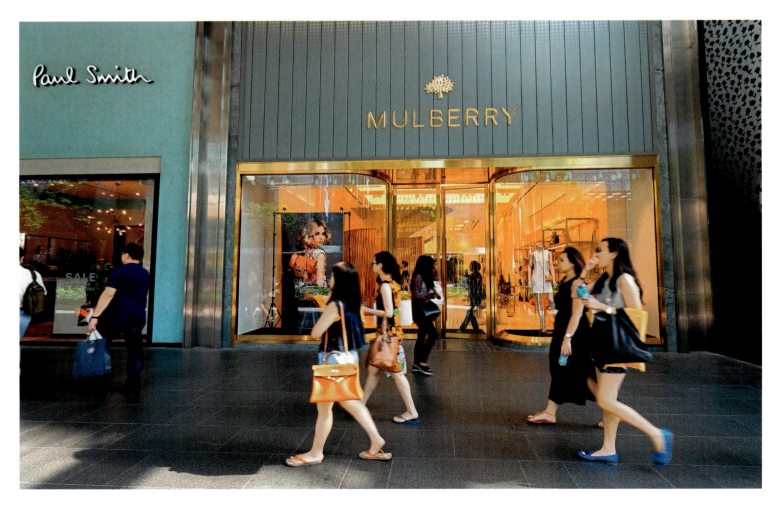

# Little India—Singapore's Most Colourful District

**Plunge into a world of colourful sights and scents in Little India's Serangoon Road.**

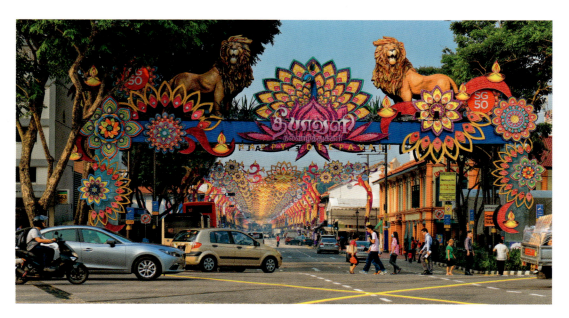

**Top left:** A quintessential Indian dish is *roti prata*, a flat bread paired with curry. Modern versions have all sorts of fillings, and ingenious names like Prata Bomb or Tissue Prata.

**Top right:** Have your fortune told at this table, where a parakeet will pick a card on your behalf and the fortune teller will interpret it for you.

**Left:** Little India is always festively decorated for Deepavali. The festivities pictured coincided with the nation's year-long golden jubilee celebrations.

**Below:** A South Indian-style wedding taking place at the Sri Sreenivasa Hindu temple.

**Right:** Sri Sreenivasa Hindu temple on Serangoon Road is dedicated to the god Vishnu. Its Gopuram roof shows the god's various incarnations.

Serangoon Road is a madly pulsating artery that runs through the heart of Little India, probably Singapore's most colourful neighbourhood. Indian workers first settled in the area when the British brought them here to construct famous landmarks like St Andrew's Cathedral, City Hall and the Istana (now the president's official residence). Indians grazed cattle here, too, for the feed was good. Street names evoke this history: Buffalo and Kerbau (Malay for buffalo), Hindoo, Veerasamy, Klang (its variant, *kling*, is a sometimes derogatory term for South Indians), together with the names of prominent persons like butcher Desker, Clive, Campbell and Kitchener, who all played greater roles in India than in Singapore.

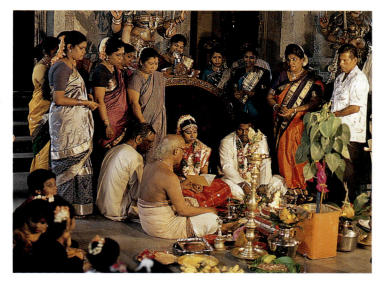

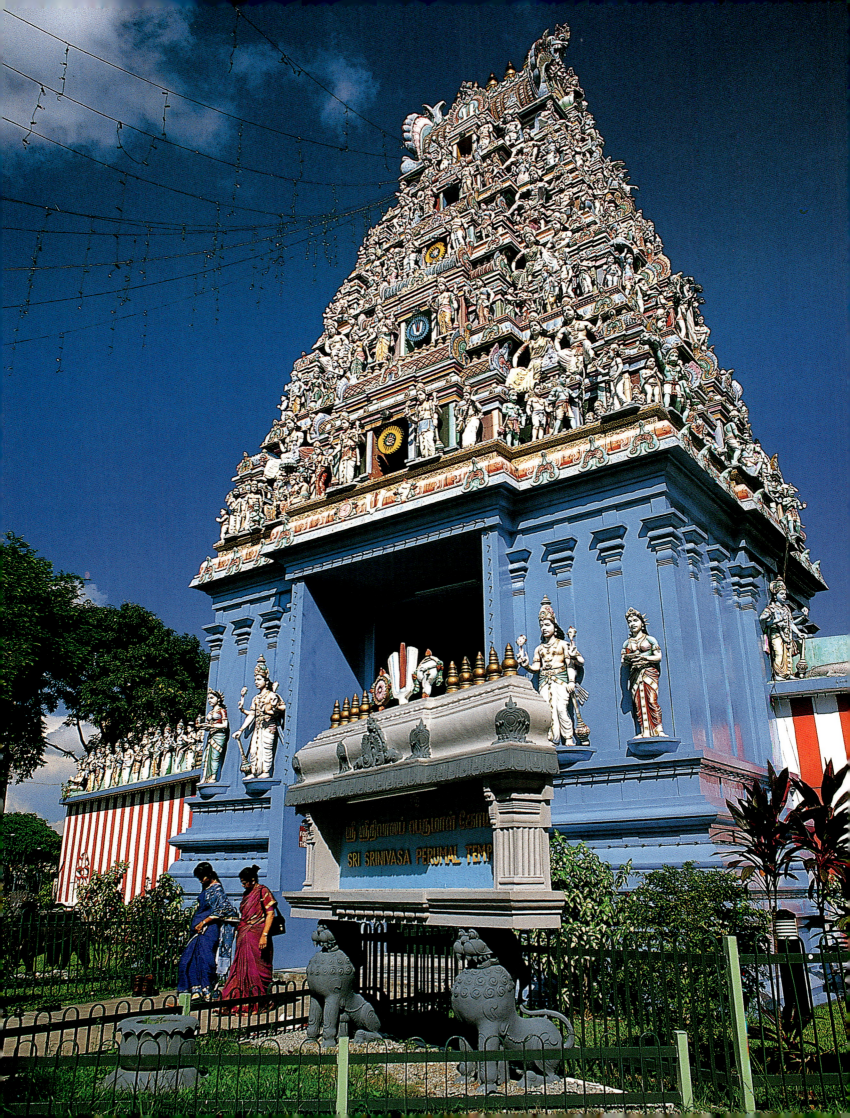

SRI SRINIVASA PERUMAL TEMP

A walk through Little India today can be an assault on the senses—all of them at once! The area is always crowded, especially on Sundays when the foreign workers have their only day off. They gather here in huge numbers and you are jostled for space on the sidewalks. There is much to see, from sari-clad or Punjabi-suited women to ornate Hindu temples. The aromas on every corner are those of India—spices, fruit and incense. Restaurants serving all sorts of dishes from various parts of India line the side streets. It's a noisy place, full of life. The best time to visit Little India is during Deepavali, the Festival of Lights, when Serangoon Road is awash in colourful lights and cheerful people.

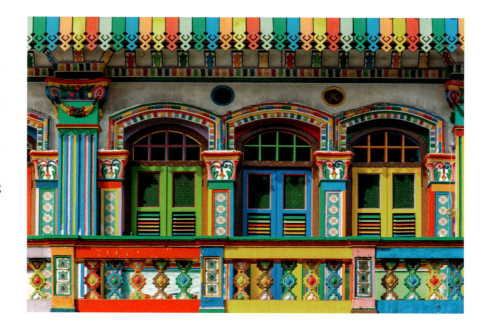

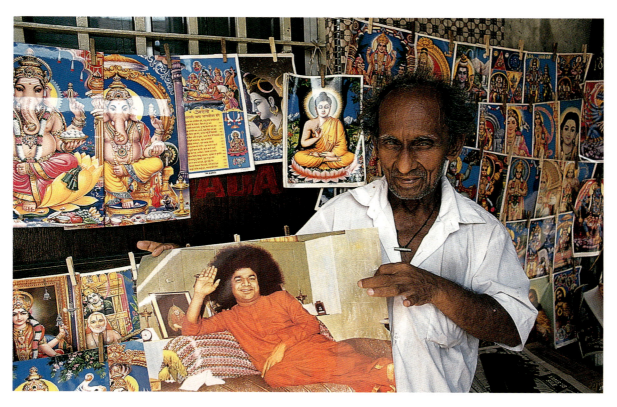

**Top:** Regarded as one of the top sights in Little India, this colourful Chinese villa once belonged to Tan Teng Niah, who built it for his wife.
**Above:** A local vendor displays a picture of Sathya Sai Baba as well as Buddha and Ganesh, the elephant god.
**Right:** In Hindu and Sikh cultures, temporary henna 'tattoos' are applied for marriage ceremonies and are now popular with tourists also.

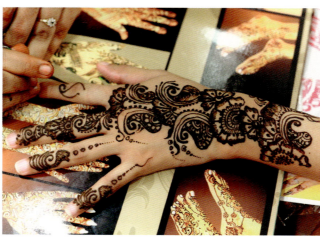

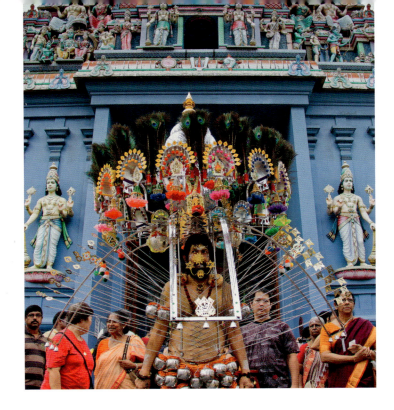

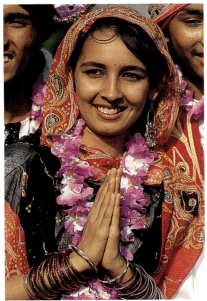

**Far left:** A devotee carries a *kavadi* after being pierced with *vel* skewers during the festival of Thaipusam.
**Left:** A woman raises her hands, palms together, in the traditional *namaste* greeting.
**Below left:** A dry goods shop in Little India. Be sure to step inside to check out the fragrant spices.
**Below right:** Floral garlands are commonly worn during ceremonies worshipping Hindu deities, such as Kali and Durga.
**Bottom right:** A tailor sits along the five-foot way of Little India repairing a pair of trousers. Travellers can also have suits or saris made here.

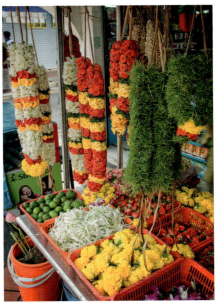

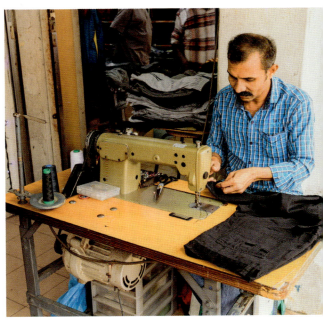

# Kampong Glam and Arab Street

This traditional cultural enclave has blossomed into a trendy hotspot with cafes and boutiques frequented by locals and tourists alike.

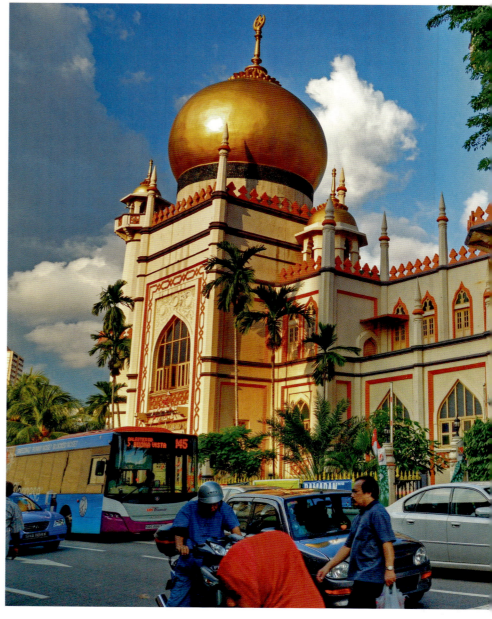

**Left and right:** Shophouses along Arab Street now house trendy cafes like the Piedra Negra shown in both pictures. **Below:** The Sultan Mosque was completed in 1826 and has a prayer hall that can seat up to 5,000 people.

Once the enclave of the Malay aristocracy, Kampong Glam, which today sits between Kallang and Rochor, was reserved in the 1822 Raffles Plan for Sultan Hussein Shah of Johor, his household and the Malay and Arab communities. The population, which later comprised not just Malays and Arabs but also Chinese and Indians, soon outgrew Kampong Glam and spread to other areas, such as Joo Chiat, Tanglin, Geylang Serai and Kampong Eunos.

The major landmark here is the Masjid Sultan, or Sultan Mosque, originally commissioned by Sultan Hussein and granted national monument status in 1975. Today, Kampong Glam retains its historical façades, restored shophouses and commercial spirit. Modern multi-label stores and boutiques, bars and cafes mix with traditional shops selling Persian carpets, batik, hand-woven textiles, hand-made perfumes and *sarung kebaya* (blouse and sarong combinations). Large crowds gather during the Holy month of Ramadan to break fast and buy festive items for the Hari Raya Aidilfitri celebrations that follow. Mingle with the locals during this festive season in the Ramadan Bazaar, which has over 1,500 stalls selling Malay cakes, curries and snacks.

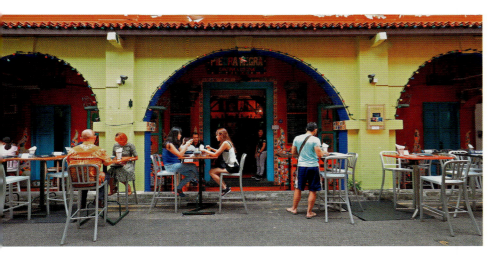

**Below:** Arab Street, offering an eclectic selection of modern and traditional items, is a popular haunt for shoppers.
**Below centre:** During the month of Ramadan, food stalls line Bussorah Street next to the mosque. These serve Arabic, Egyptian, Indonesian and Malay dishes, popular not only with Muslims but with people of all ethnicities.
**Bottom:** Colourful murals adorn the sides of the shophouses in Arab Street, lending colour to the neighbourhood all year round.

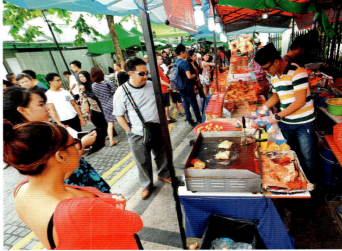

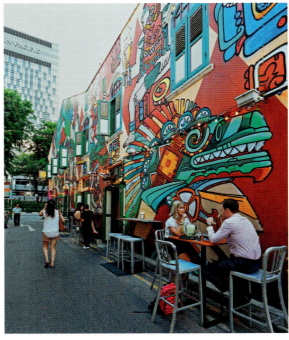

# Singapore's Famous Botanic Gardens

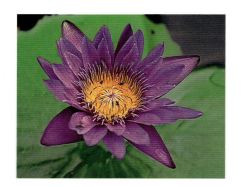

Surprisingly for one of the world's mostly densely populated countries, more than 30 per cent of Singapore is green space. It all started with the Botanic Gardens, which have recently been declared a UNESCO World Heritage Site.

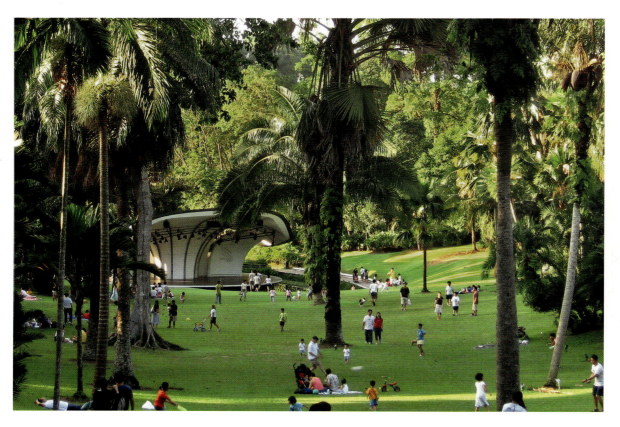

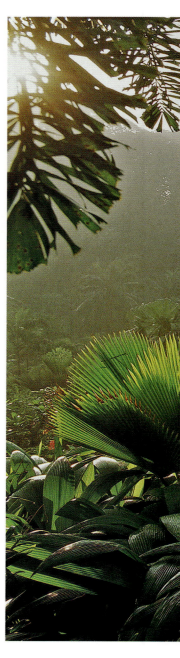

**Top:** A purple water lily in bloom.
**Above:** The gardens around Symphony Lake are great for families and picnics, and there are free concerts on weekends.
**Right:** People practising Tai Chi. The gardens are also popular for yoga and jogging.
**Far right:** The National Orchid Garden has many locally bred hybrids.
**Opposite above:** The new entrance to the Botanic Gardens facing Napier Road.
**Opposite below:** A vestige of the equatorial rainforest which once covered all of Singapore.

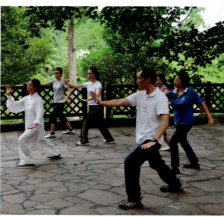

Singapore is one of the world's most densely populated nations, averaging over 5,000 residents per square kilometre. Yet green spaces are found throughout the island. The 50-hectare Botanic Gardens, recently declared a UNESCO World Heritage Site, is one of the largest and most important of these. The gardens are bounded by Holland Road, Tyersall Avenue, Bukit Timah Road and Cluny Road.

The gardens were created in 1859 by colonial figures such as Laurence Niven, the owner of a nearby nutmeg plantation. He supervised the gardens' layout and the clearing of the jungle where tigers still roamed. One of the most interesting characters associated with the Botanic Gardens was Sir Henry Ridley, the director from 1888 to 1912, who developed a new way to

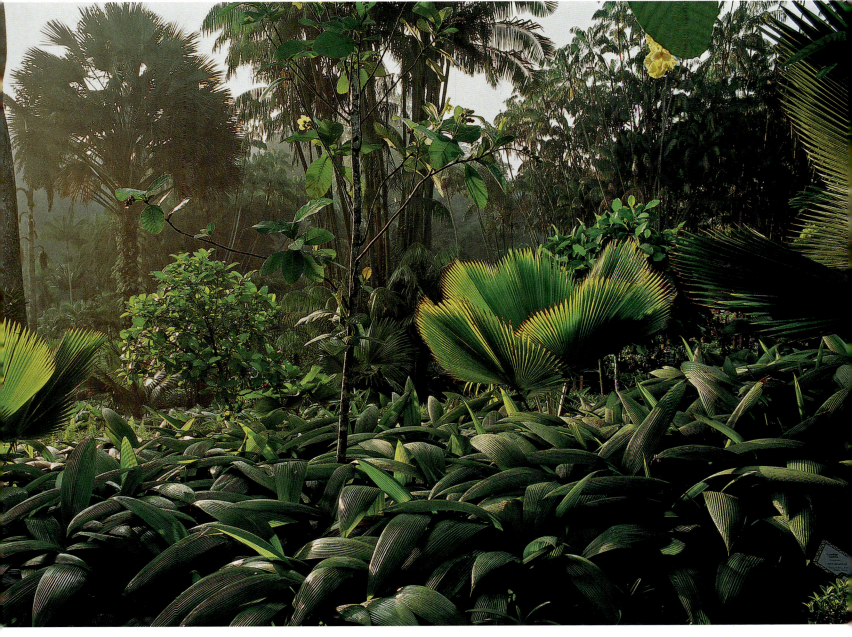

tap latex from the trees that did not kill them. Within two decades, the Malay Peninsula became the world's leading source for rubber, supplying half the world's latex.

Among the gardens' attractions are the National Orchid Garden, which houses the national flower, Vanda Miss Joaquim, orchid hybrids named for state visitors and VIPs, and a six-hectare primary rainforest comprising 314 different species of plants. A new Heritage Garden was opened in 2016, featuring more than 80 species of plants, such as bougainvilleas and yellow cow wood trees. Future developments include an expansion of the children's teaching garden (the Jacob Ballas Children's Garden) and The Learning Forest to be completed in 2018. Also found here are a Visitor's Centre with shops and restaurants, and the Shaw Foundation Symphony Stage at Symphony Lake, where free open-air concerts are given on weekends, weather permitting.

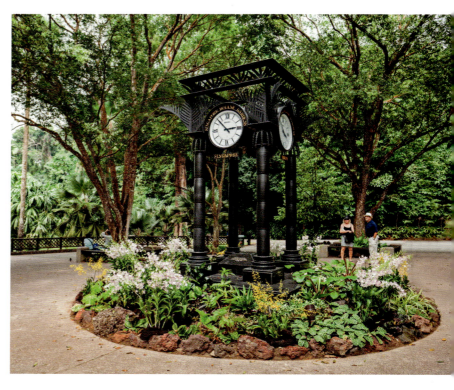

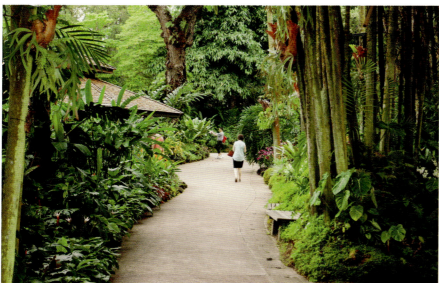

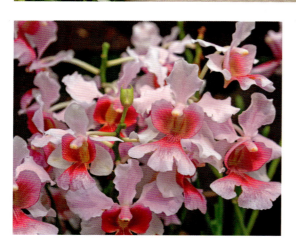

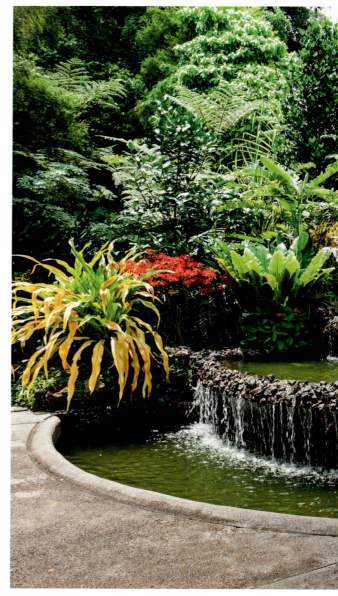

**Top:** The clock tower designed by Eng Siak Loy displays the time in Japan, Canada, the UK and Singapore on different sides.
**Above:** A relaxing stroll in the Botanic Gardens, open from 5 am to 12 midnight every day, is a must for visitors to Singapore.
**Left:** Singapore's national flower, the Vanda Miss Joaquim.
**Right:** Crane sculptures, a congratulatory gift from Lady Yuen-Peng McNeice, who also donated the clock tower.

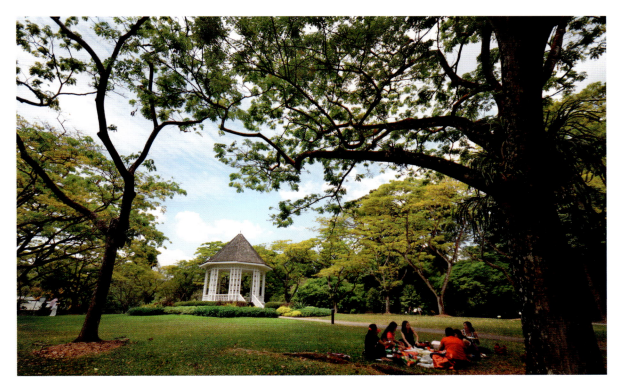

**Below:** The National Orchid Garden, which houses 60,000 orchids, including Singapore's national flower, the Vanda Miss Joaquim, is the only part of the Botanic Gardens where an admission fee is charged.

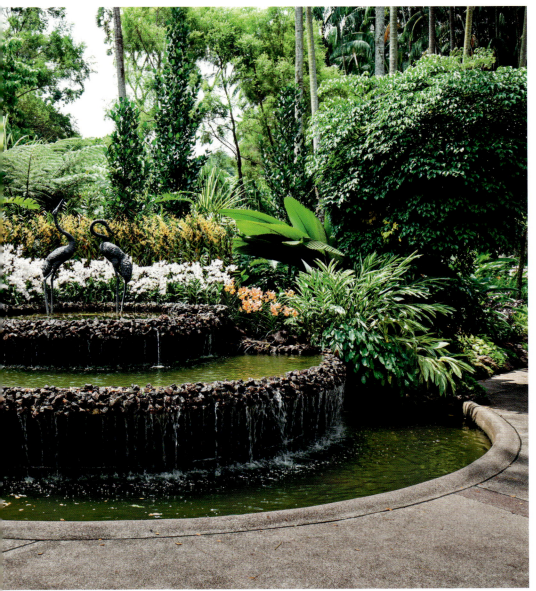

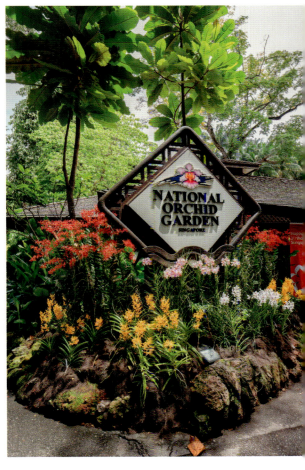

# Sentosa Island—A Tropical Playground

Singapore is constantly reinventing itself. The sleepy isle of Pulau Belakang Mati has been transformed into a tropical playground with sandy man-made beaches and a multi-billion-dollar casino complex with a Universal Studios theme park featuring duelling roller coasters.

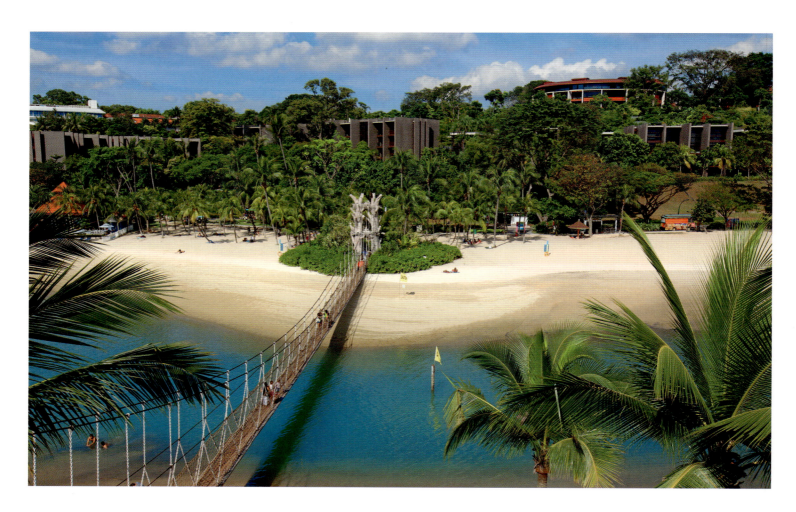

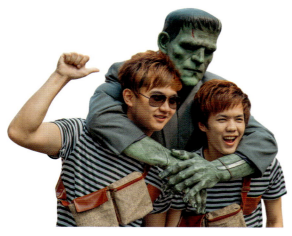

Sentosa was not always the carefree resort island it is today. In the 1880s, the British built Fort Siloso on the western tip of the island, known then as Pulau Belakang Mati ('The Island Where Death Lurks'). The fort, intended to protect the entrance to Singapore harbour, was strategically unimportant until World War II, the island's darkest hour. However, the Japanese attack came not from the sea as expected but from the Malayan peninsula to the north.

**Top:** Spend a day lounging on one of Sentosa's three beaches.
**Above:** A rope bridge leads from Palawan Beach to a small man-made island in a lagoon.
**Left:** A photo opportunity with Frankenstein's monster in Universal Studios Singapore.
**Right:** The 11-storey Merlion on Sentosa has an elevator so visitors can take in the views from its mouth and head. At night, fibre optic and laser lights change its colour.

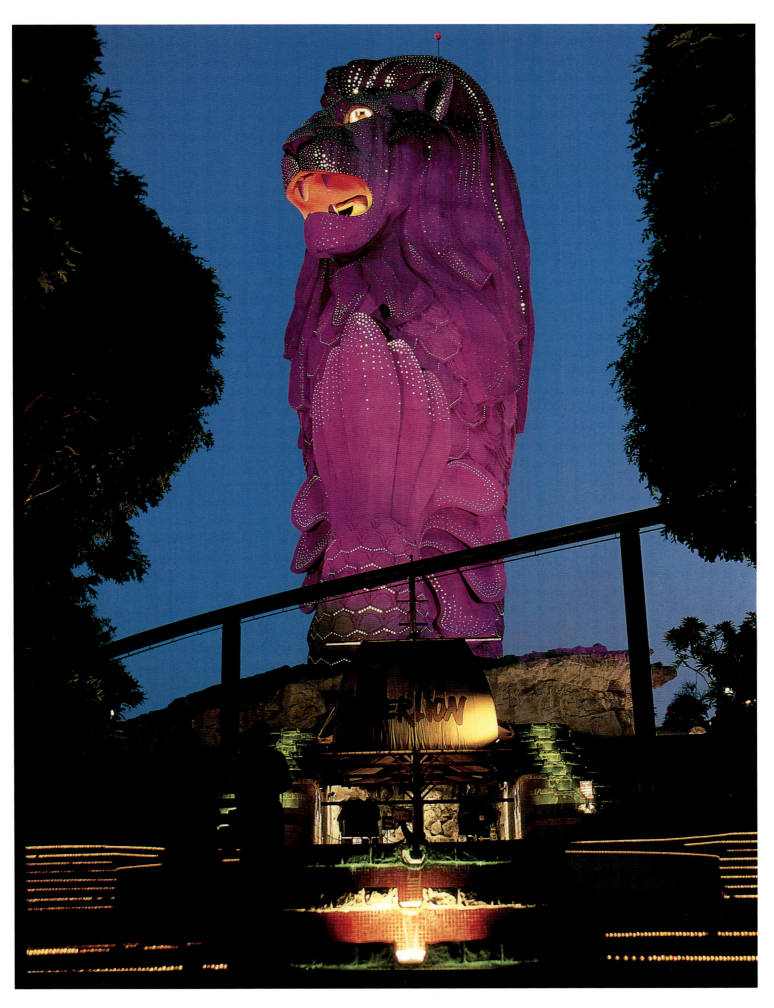

Singapore was taken by the Japanese and Fort Siloso became a prisoner-of-war camp. The island, appropriately renamed Sentosa ('Peace' in Malay), was relaunched in the 1980s as a major tourist attraction. Fort Siloso is now a World War II museum.

Attractions abound on Sentosa, including the Universal Studios theme park, the S.E.A. Aquarium, the Trick Eye Museum, Madame Tussauds Wax Museum and the Adventure Cove Waterpark. Thrill seekers can zipline above the trees at MegaZip Adventure Park, go 'skydiving' at iFly or swing like an acrobat at the Flying Trapeze. You can get around the island by the Sentosa Express monorail, tram or bus, although you can also hire a bike or walk. Sentosa is a great place to escape from the hustle and bustle of the city.

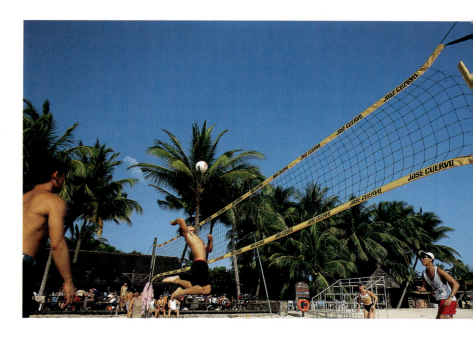

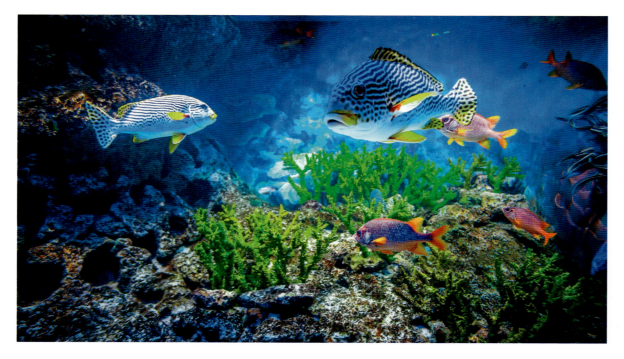

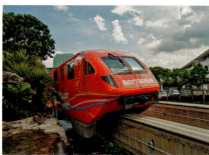

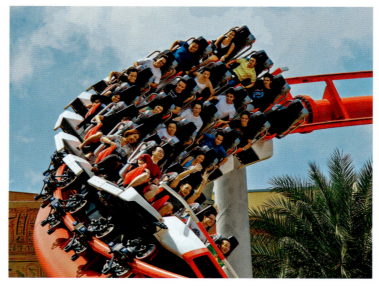

**Above:** The Sentosa Express monorail brings visitors from VivoCity on the mainland to points around the island.
**Right:** The most thrilling ride at Universal Studios is Battlestar Galactica. This twin duelling roller coaster pits the Human track, pictured here, against the Cylon track.

**Left:** Enjoy a game of volleyball on Siloso Beach, one of three man-made beaches on Sentosa.

**Opposite centre:** Be mesmerized by fish in the S.E.A. Aquarium. The marine life on display includes leopard sharks and manta rays.

**Right:** Universal Studios Singapore is the first Universal Studios theme park in Southeast Asia.

**Below:** A view of Sentosa from the mainland at VivoCity. Visitors can walk to the island for free via the Sentosa Boardwalk or take the Sentosa Express monorail.

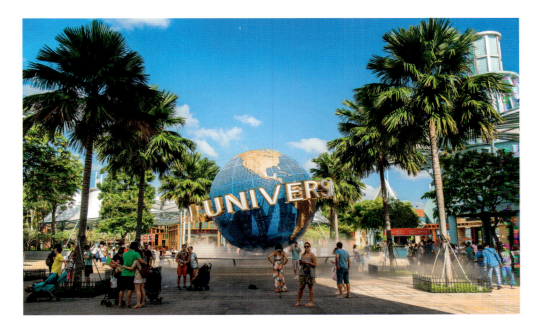

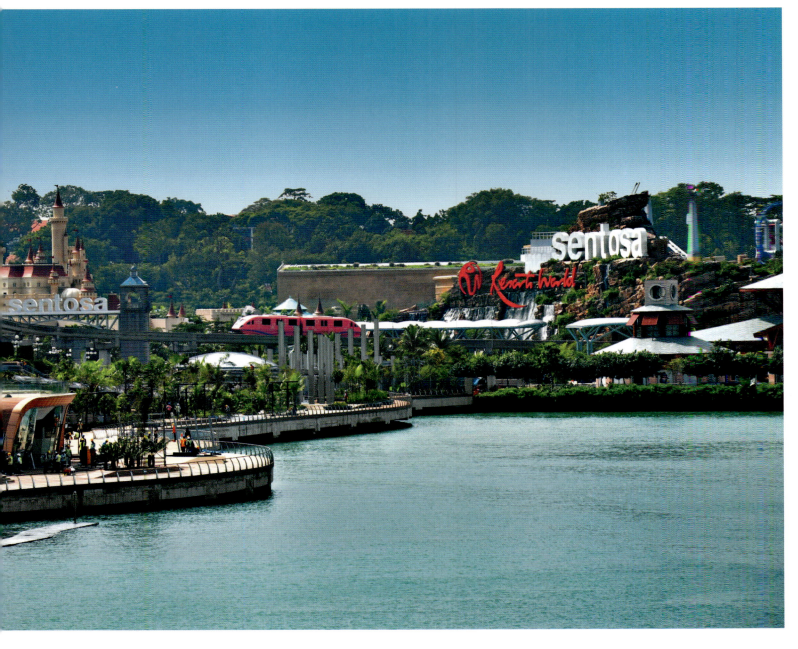

# The Singapore Zoo, River Safari and Night Safari

The Singapore Zoo, one of the world's finest, is home to rare and endangered tropical species who are free to roam in open pen areas. More recent activities include the Night Safari, a separate attraction open in the evening, and the River Safari, featuring a river boat jungle cruise.

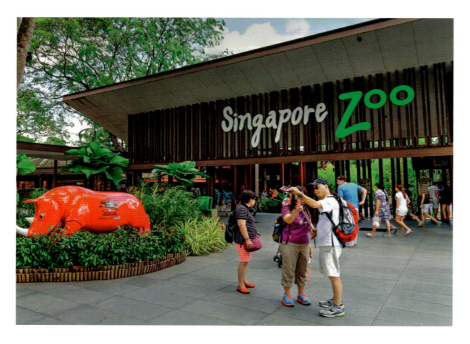

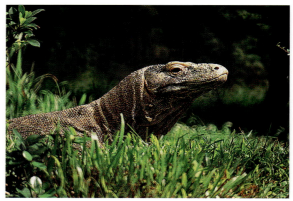

**Above:** The entrance to the Singapore Zoo, which is visited by 1.7 million people annually.

**Above right:** The Komodo dragon is a rare species of monitor lizard found on only a few islands in eastern Indonesia. These carnivores grow up to 3.5 metres long, weigh as much as 130 kilograms and use their poisonous saliva to help overcome large prey such as deer.

**Opposite top left:** Many people mourned the loss of the zoo's animal ambassador Ah Meng. Her granddaughter Ishta took over this role in 2016, and she can be seen four times a week at the Jungle Breakfast with Wildlife experience.

**Opposite top right:** The Thumbuakar warriors display their flame throwing skills and an array of amazing stunts hourly from 7 pm onwards at the Night Safari.

**Opposite below:** A number of free shows are presented at the Singapore Zoo, including the Elephants at Work and Play show, where elephants lift giant logs and playfully spray water at the audience.

The Singapore Zoo opened in 1973. Now ranked among the best in the world, it had its origins in the 1960s when the families of British military forces pulled out after independence, leaving many animals behind. About 26 per cent of the more than 300 species are classified as threatened. These are among the zoo's 2,800 animals. The Singapore Zoo joins international breeding programmes for rare animals. A successful example was the surprise birth of a polar bear, Inuka. The zoo's 100 hectares allow many of the animals to be kept in open enclosures bounded by natural rock walls and moats rather than in barred cages. Regular feeding times are scheduled throughout the day for various groups of animals. Attractions such as Children's World and playgrounds cater especially to the interests of younger visitors. The most recent additions were four adorable koala bears on a six-month loan from Australia to celebrate the strong international ties between the two countries.

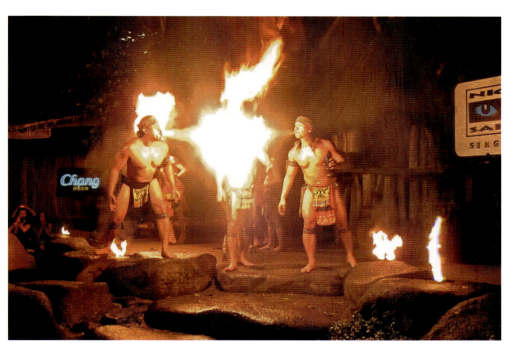

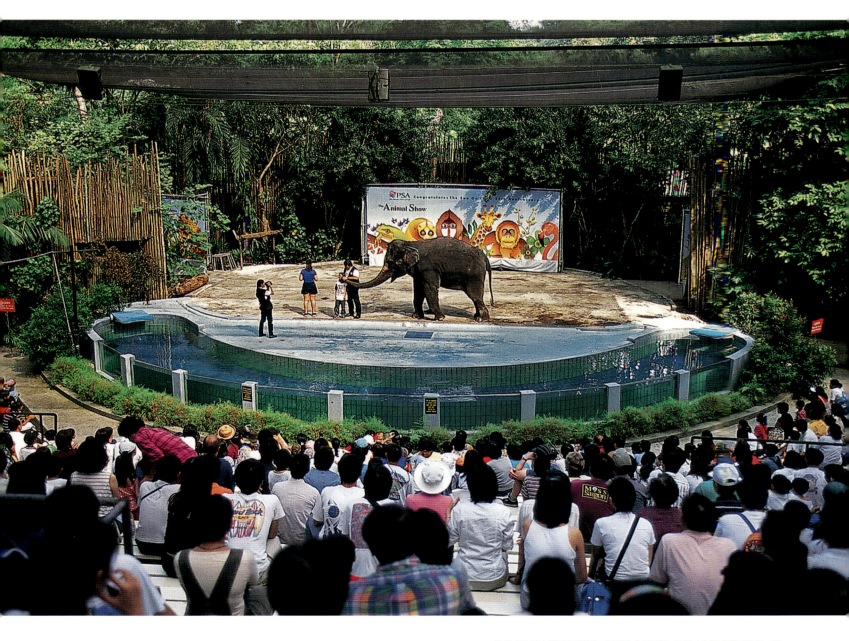

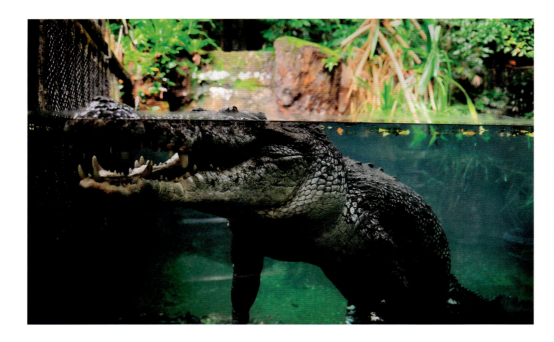

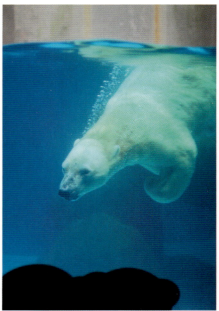

**Above:** The largest living reptile, the crocodile, is housed in a plate glass sheltered viewing pool for visitors to safely follow its movements underwater. There is also a feeding show for crocodiles at 4.45 pm on Sundays.

**Top right:** Inuka, the first polar bear born in the tropics, keeps cool in a Frozen Tundra refrigerated pool, specially built to mimic his Arctic habitat.

**Right:** The Amazonian Flooded Forest in the River Safari is the largest freshwater aquarium in the world, and features piranhas and the araipama.

**Below left:** Guests can get up close to the Aldabra giant tortoise in the Reptile Garden. Tortoises can live to be 152 years old.

**Below right:** A meerkat peers out from its hiding place in the Wild Africa zone in the zoo.

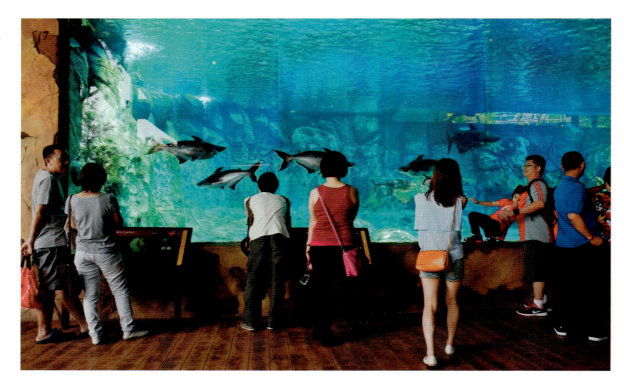

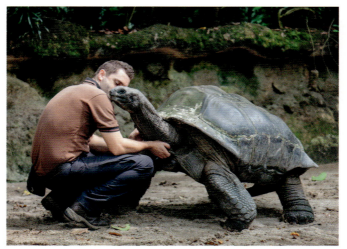

**Right:** On loan from China for ten years is a pair of giant pandas, Kai Kai and Jia Jia, part of the River Safari.

**Below:** Leopards are generally more active at night and are best seen on the Leopard Trail at the Night Safari.

**Below right:** There are several animal performances at the zoo, including the Rainforest Fights Back show where animals display their amazing skills.

**Bottom:** The Night Safari welcomes about 1.1 million visitors annually, who come to see more than 2,500 animals in their nocturnal habitats.

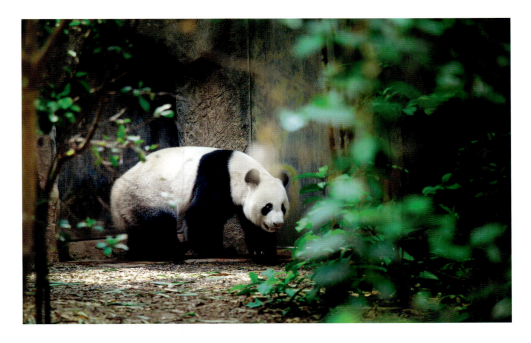

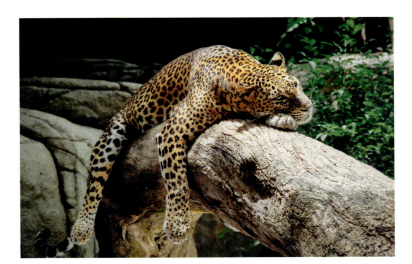

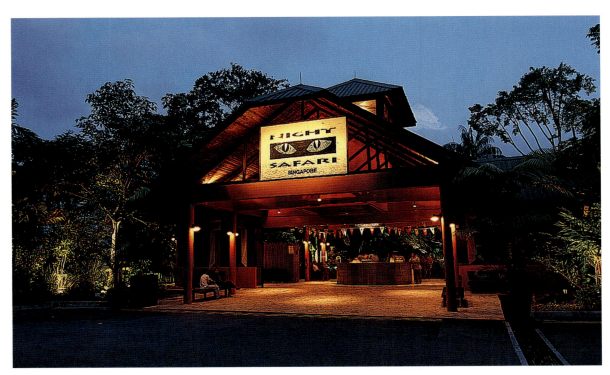

# The Jurong Bird Park

This sprawling 20-hectare park, served by a tram, has more than 400 bird species from all over the world.

The award-winning Jurong Bird Park is an extraordinary 20-hectare home for more than 5,000 birds from 400 different species, many flying free in a 2-hectare walk-in aviary featuring a 30-metre man-made waterfall. Various shows are scheduled, or you can simply stroll through the gardens and keep your eyes open. Feeding times are great for kids to have a closer encounter with the birds, including ostriches, penguins, lories and flamingos. If you become tired, hop aboard a guided tram around the park, complete with informative commentary. The park will be relocated to the Mandai nature precinct by 2020.

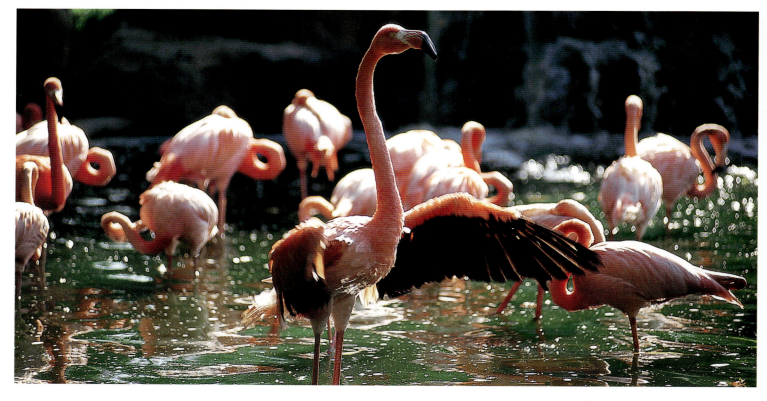

**Top left:** A friendly parrot perching on a visitor's shoulder at the Lunch with Parrots.

**Top right:** The Jurong Bird Park is Asia's largest bird park with the world's largest lory flight aviary.

**Centre:** The much-photographed Flamingo Lake is home to greater and lesser flamingos.

**Far left:** A large hornbill demonstrating its talents at the High Flyers show. The park has been successful in conserving and breeding this rare species.

**Left:** The park's expert falconer performing at the King of the Skies show, which features the white-tailed sea eagle, the hooded vulture and the Harris hawk.

# The Jurong Lake Gardens

The Chinese and Japanese gardens provide havens of tranquility on two huge islands in Jurong Lake at the western end of Singapore. Plans are afoot to develop the 90-hectare Jurong Lake Gardens into Singapore's central park.

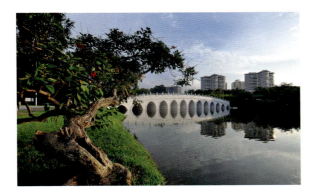

Linked by the Bridge of Double Beauty, these two gardens are peaceful havens for city dwellers. The Chinese Garden features several pagodas, including one styled after the Beijing Summer Palace. The Herb Garden and the Garden of Fragrance are delightful. Also called 'The Garden of Tranquility', the Japanese Garden has stone lanterns, trimmed shrubs and a miniature waterfall. Its classical features also include summer houses and Zen rock gardens. When the new Jurong Lake Gardens is completed in 2018, these two gardens will form the central core, flanked by Jurong Lake Park and the grounds of the new Science Centre.

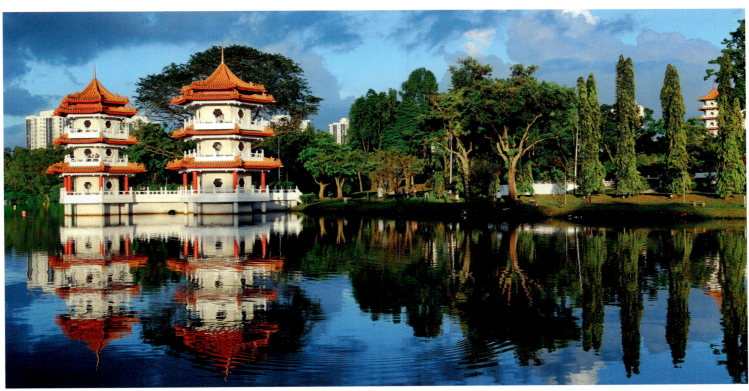

**Top:** Double Beauty Bridge follows the style of the Seventeen Arch Bridge in the Summer Palace in Peking, and was the finish line of *Amazing Race Asia 2*.
**Above:** One of the most distinctive sights in the Chinese Garden is the Twin Pagodas. A third pagoda lies on a small hill and resembles Nanjing's Ling Ku Temple Pagoda.
**Right:** The Main Arch Building features two courtyards and a fish pond, and is an example of a traditional Chinese arch gateway.

# Changi Airport—Best in the World

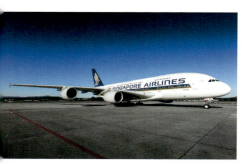

Singapore's highly acclaimed airport is constantly reinventing itself. Among forthcoming developments are the Jewel Changi Airport complex, two massive new terminals and a new runway.

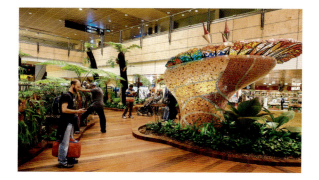

Singaporeans really like visiting their airport, even when they're not travelling. It has recently won its 500th Best Airport award. The airport currently has three terminals, with another two in the development stages. It also has many unusual amenities, such as the country's tallest slide and a butterfly garden. Currently, Terminal 1 has 56 shops and 24 cafes, restaurants and bars. When ready in 2019, the new Jewel Changi Airport complex at Terminal 1 will be a lifestyle destination in its own right, with 22,000 square metres of space housing one of the largest collections of indoor plants at the five-storey Forest Valley as well as four different Gateway Gardens. One of its main attractions will be the 40-metre-high Rain Vortex, the world's tallest indoor waterfall, complete with its own light and sound show. Jewel Changi will also have walking trails, dining outlets, playgrounds, shops, an integrated multi-modal transport lounge and a transit hotel.

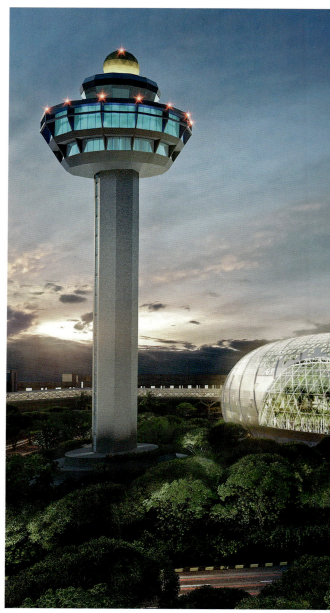

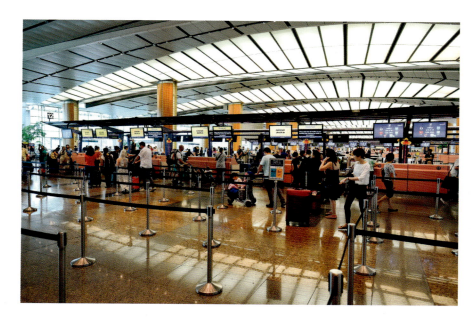

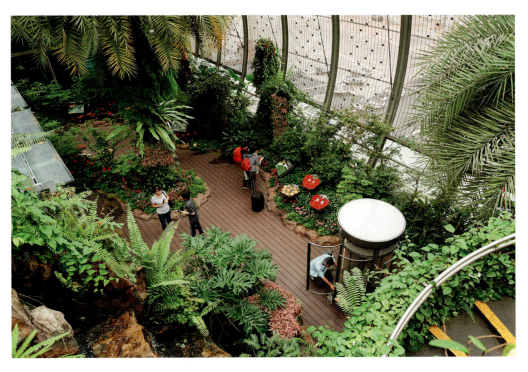

**Opposite:** Over 100 international airlines serve Changi Airport, including, of course, home-grown Singapore Airlines.

**Left:** The Enchanted Garden in Terminal 2 comes to life with the sounds of nature and blooming flowers. Optic fibre and LED lights form a sparkling pathway at night.

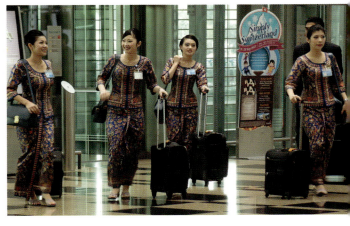

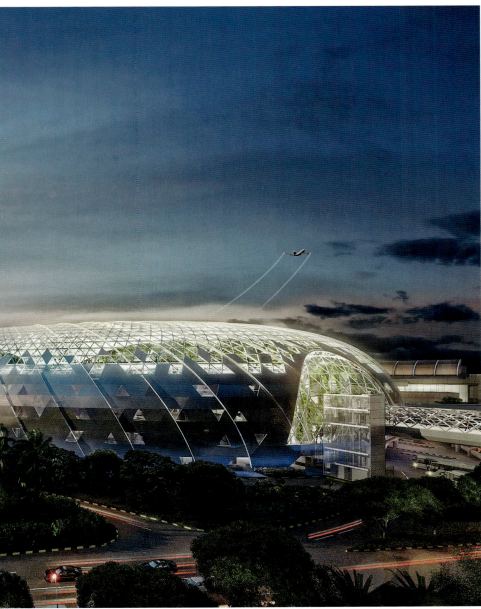

**Top:** The airport's Butterfly Garden houses more than 1,000 butterflies and a 6-metre grotto waterfall.

**Left:** The new Jewel Changi terminal will connect Terminals 1, 2 and 3 and feature a 40-metre-high waterfall.

**Above centre:** Singapore Girls—the flight crew of Singapore Airlines—in their batik *sarung kebaya* designed by Pierre Balmain in 1968 are a common sight at Changi.

**Above:** The airport has hundreds of shops, cafes and restaurants, which are required by law to charge the same prices as in the city.

# Singapore Food—A Gourmand's Delight

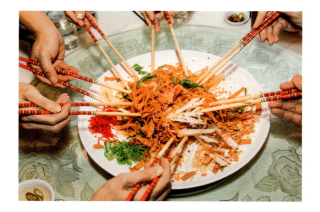

**Many people, locals and visitors alike, say the food in Singapore is among the finest in the world. Who's arguing?**

**Left:** *Yusheng*, a dish served only during the Chinese New Year holiday, was created by the Four Heavenly Culinary Kings of Singapore in 1964. Its 27 ingredients are tossed by family members, colleagues or friends to bring luck for the coming year.
**Below:** Stacks of steamer baskets hold *dim sum* dishes at the food court at Marina Bay Sands. These contain bite-sized portions of shrimp dumplings, carrot cake, pork buns and *xiao long bao*—dumplings filled with meat and broth.

Singaporeans, it is said, do not eat to live, they live to eat. That's a good policy in a nation with arguably the finest food in the world. You also get excellent value for money as it is still possible to eat well at hawker centres for a few dollars. At the other end of the scale are top restaurants helmed by famous names like Gordon Ramsay, Joel Robuchon and Tetsuya Wakuda at $300 a head. No single dish defines Singaporean food since the country's cuisine has been drawn from many lands—China, India, Indonesia, Malaysia and the best of the West. Famous dishes to try include *nasi lemak*

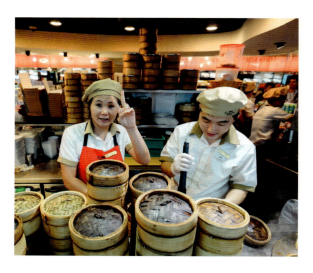

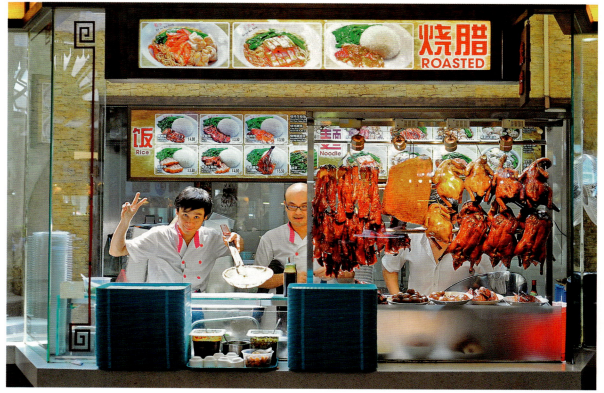

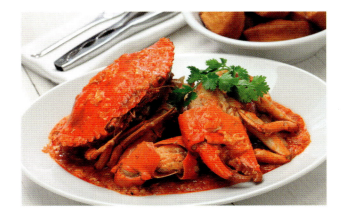

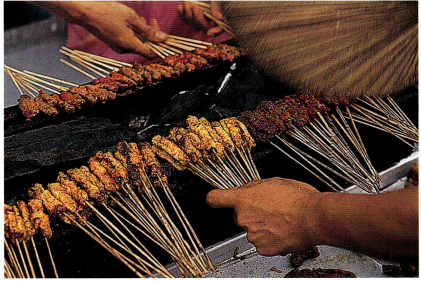

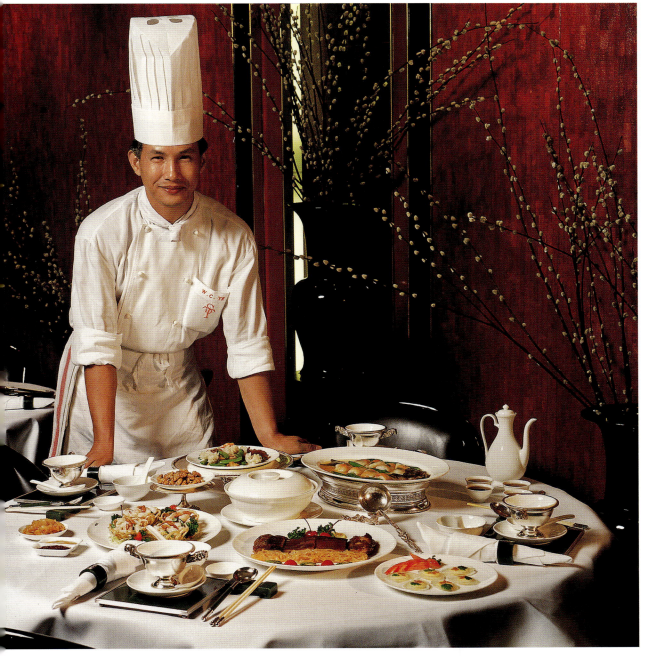

**Above left:** Chilli crab, a favourite local dish, is smothered in a sweet spicy tomato sauce. It is usually served with crusty French bread or steamed or fried buns (*mantou*) for dipping into the sauce. Other famous crab dishes include black pepper crabs, salted egg yolk crabs and steamed crabs. These can be found in seafood restaurants all over the island.

**Top:** Another local favourite is satay—seasoned chicken and beef on skewers grilled over a fire—paired with onion, cucumber and pressed rice cubes all dipped in a spicy sweet peanut sauce.

**Left:** A banquet at Li Bai Cantonese Restaurant at Sheraton Towers Hotel on Scotts Road. Chinese cuisine in Singapore consists of a mixture of Cantonese, Teochew, Hainanese and Hokkien dishes.

**Opposite bottom:** A roasted meat stall commonly found in food courts, coffee shops and hawker centres across the country. Favourite dishes are *char siew* rice, roast pork, duck rice and, of course, Singapore's iconic chicken rice.

**Right:** *Laksa* is a local dish of rice noodles in a rich coconut broth, usually paired with chicken, fish or prawns.
**Below:** A plate of chicken rice, Singapore's national dish. Its condiments include garlic chilli, fresh ginger and black soya sauce.
**Below right:** Economy rice stalls typically sell various vegetable, chicken, pork and fish dishes. Simply point at what you want and it is scooped over a plate of rice. It all costs just a few dollars.

**Bottom:** Locals having dinner at a *zi char* food stall in Chinatown, where they order several dishes to share.
**Opposite top left:** The famous Lim Chee Guan *bak kwa* (barbecued pork sheets) is especially popular during Chinese New Year, where the wait may be a few hours.

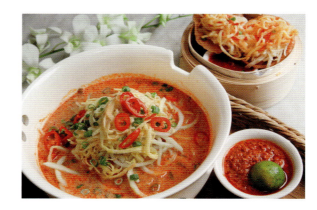

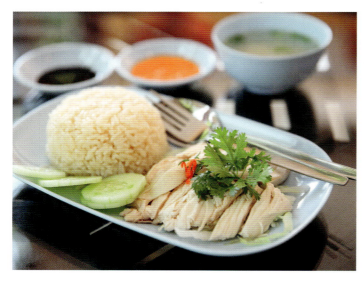

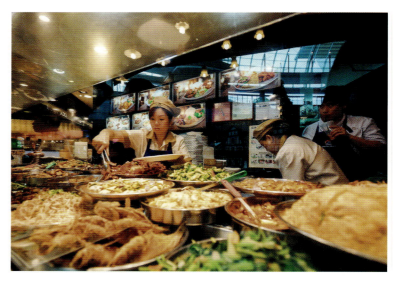

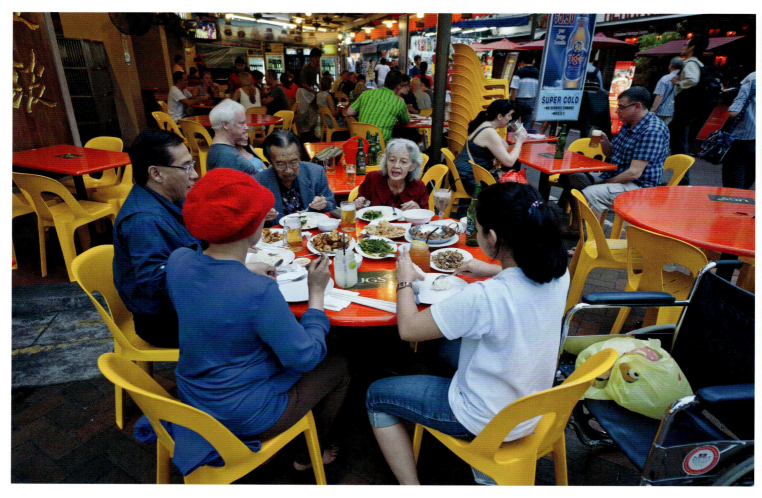

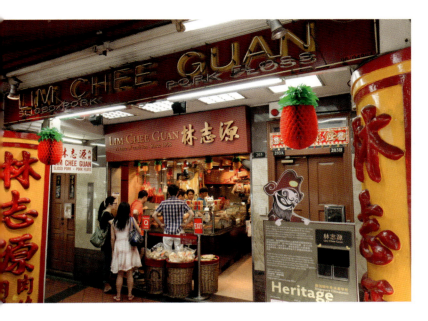

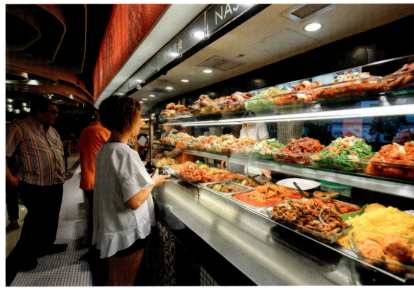

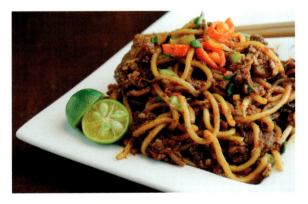

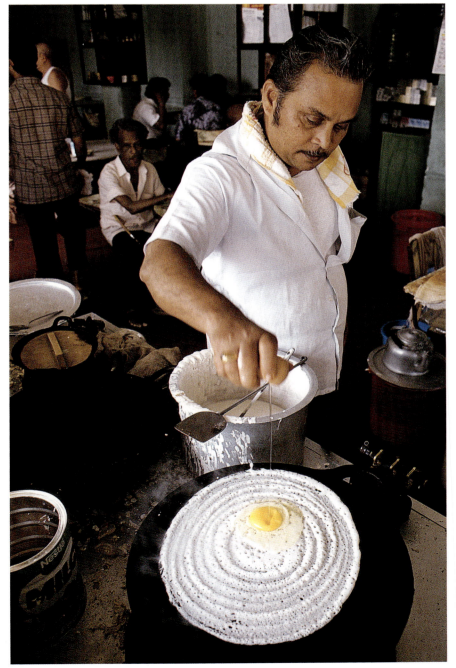

(a staple Malay breakfast), fish head curry, Hainanese chicken rice, chilli crab, satay, *roti prata* (Indian bread with curry, a great way to start the day), and Hokkien fried noodles. Of course, you must also sample the tropical fruits, such as rambutans, mangoes and mangosteens. Or try a famous local dessert. Many have shaved ice as their base. *Ice kacang* (ice mountain) includes red beans and sweet syrup among its colourful ingredients. *Chendol* contains red beans, coconut milk and brown sugar. *Bubur chacha* and *bubur hitam* both feature sweet potato, yam and coconut milk. Barley-rich *chng tng* is delicious hot or cold. Food is preferably eaten in the company of friends, family or colleagues, because eating in Singapore is an important social activity.

**Top right:** Indonesian *nasi padang* originated from west Sumatra and features fiery hot precooked vegetable, meat and fish dishes.
**Above:** The spicy *mee goreng* or fried egg noodles with chicken, onions, beansprouts and grilled beancurd. Variations of this dish include *ikan bilis mee goreng* and *Maggi mee goreng* (where instant noodles are used).
**Left:** An Indian hawker making *thosai* (a pancake made from fermented bean and rice flour), which is served with chutney.

# Singapore Swings!

The Lion City is not exactly known for its nightlife, but when the sun goes down Singapore transforms into Swingapore.

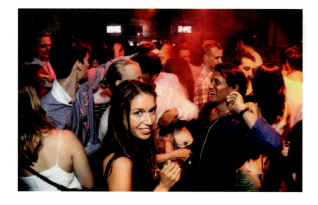

**Above:** Popular spots for clubbing can be found in the Mohammad Sultan area, Clarke Quay and Tanjong Pagar.
**Below left:** Beyoncé performs at F1 Rocks during the Formula One weekend. This event has attracted headliners like Maroon 5, Bon Jovi, Pharrell Williams and BIGBANG.

**Below:** Meadow at Gardens by the Bay hosted the St Jerome's Laneway Music Festival featuring electronic band Cvrches and local bands Riot! and Cashew Chemists.

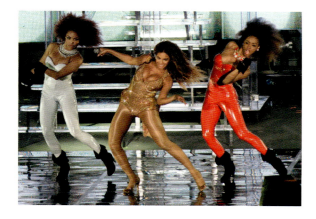

Singapore is becoming funkier by the day, it seems. This little island nation offers bars and dining by the river as well as big clubs such as Zouk, Attica, Trace Lounge, Pangaea, Kyo and Altimate. Between them, they appeal to all tastes, with customers ranging from young teenagers wearing the latest designer label clothing to middle-aged men and women. Many of the clubs run special themed parties when people really get into the spirit of things. Besides Orchard Road, there are pubs and clubs in the restored shophouses of Tanjong Pagar, in a relocated and cleaned-up Bugis Street, in trendy Holland Village and in Mohammad Sultan Road. The zoo, however, offers Singapore's wildest nightspot—the Night Safari.

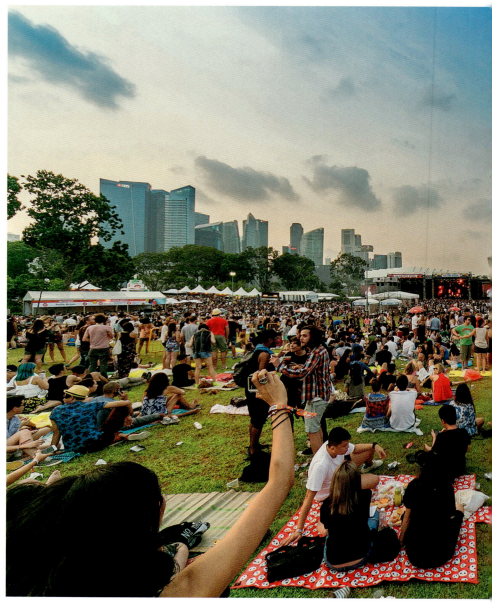

**Left:** A local band performs at Home Club (now Canvas) at Clarke Quay. Resident DJs at Canvas include Ben Nicky, Matt Smallwood and SOUL:UTION.
**Below:** ZoukOut, one of Asia's biggest outdoor beach parties, is usually held on the first weekend of December. Big names like Paul van Dyk and David Guetta have graced the occasion.
**Bottom:** The New Asia Bar on the 71st floor of Swissotel The Stamford has been voted one of the top 50 bars in the world.

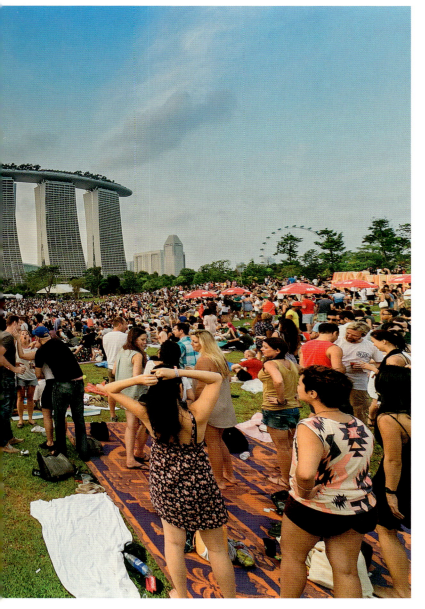

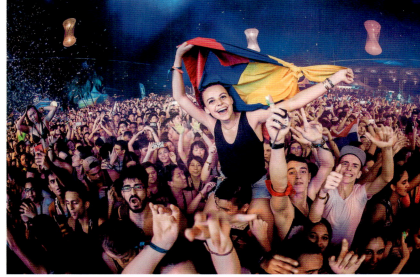

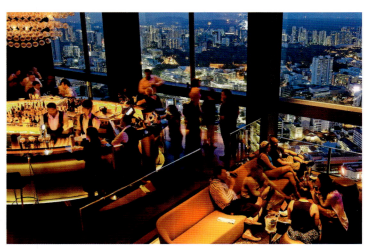

Published in 2016 by Tuttle Publishing, an imprint of Periplus Editions (HK) Ltd.

**www.tuttlepublishing.com**

Library of Congress Control Number: 2016944503

ISBN 978-0-8048-4712-4
(This title was previously published with the ISBN 962-593-207-0)

**Distributed by**

**Asia Pacific**
Berkeley Books Pte. Ltd.
61 Tai Seng Avenue #02-12, Singapore 534167
Tel: (65) 6280-1330; Fax: (65) 6280-6290
inquiries@periplus.com.sg; www.periplus.com

**North America, Latin America & Europe**
Tuttle Publishing
364 Innovation Drive
North Clarendon, VT 05759-9436 U.S.A.
Tel: 1 (802) 773-8930; Fax: 1 (802) 773-6993
info@tuttlepublishing.com; www.tuttlepublishing.com

19 18 17 16      6 5 4 3 2 1      1607RR

Printed in China

TUTTLE PUBLISHING® is a registered trademark of Tuttle Publishing, a division of Periplus Editions (HK) Ltd.

**Front endpaper:** The façade of the Marina Bay Sands and the Gardens by the Bay conservatories. The integrated resort includes a large casino, seven restaurants helmed by celebrity chefs, shops, a skating rink and two theatres.
**Back endpaper:** The Supertrees at the Gardens by the Bay measure between 25 and 50 metres. At night they come alive with a dazzling light and sound display.

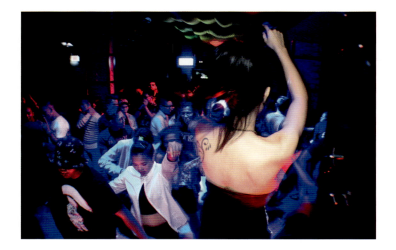

# About Tuttle
## "Books to Span the East and West"

Our core mission at Tuttle Publishing is to create books which bring people together one page at a time. Tuttle was founded in 1832 in the small New England town of Rutland, Vermont (USA). Our fundamental values remain as strong today as they were then to publish best-in-class books informing the English-speaking world about the countries and peoples of Asia. The world has become a smaller place today and Asia's economic, cultural and political influence has expanded, yet the need for meaningful dialogue and information about this diverse region has never been greater. Since 1948, Tuttle has been a leader in publishing books on the cultures, arts, cuisines, languages and literatures of Asia. Our authors and photographers have won numerous awards and Tuttle has published thousands of books on subjects ranging from martial arts to paper crafts. We welcome you to explore the wealth of information available on Asia at **www.tuttlepublishing.com.**